The Japanese
Ink Painting
Handbook

The Japanese Ink Painting Handbook

This book is dedicated to my teachers, who patiently provided guidance and inspiration, and to my students, who challenged my ideas and abilities. My hope is that the teachings in this book will convey the great joy that I find in painting, and will inspire you on your Sumi-e journey.

Susan Frame

FALL RIVER PRESS

Creative Director: Sarah King
Designer: Debbie Fisher & Co

Fall River Press
122 Fifth Avenue
New York, NY 10011

ISBN: 978-1-4351-1744-0

Material from this book previously appeared in *Japanese Ink Painting -
Beginner's Guide to Sumi-e*

Printed and bound in Singapore

10 9 8 7 6 5 4 3 2 1

CONTENTS

Introduction

What is Japanese Ink Painting?

Sumi-e is a Japanese word that literally means "ink picture". "Sumi" is the ink. Adding the "e" makes it "ink picture". In many parts of the Western world today, the word "Sumi-e" refers to any ink painting derived from traditional Asian brush techniques. The art of Sumi-e originated in China about 6000 years ago as calligraphy. Calligraphy led to painting. The first ink painting on silk dates to about 200 B.C..

Mums and Plum in Blue Vase,
by Kay Stratman.

cherry blossoms!
and from my brush
the cuckoo's song

by Jeanne Emrich.

During the Southern Sung Dynasty (A.D. 1127–1276), great advances were made in the styles of painting that emphasized a direct feeling for life and spontaneity in brushwork. It was also at this time that Zen Buddhist monks took ink painting to Japan and other parts of Asia.

Today, ink painters can be found all over the world. Sumi-e artists come from Asian, as well as non-Asian, countries and from many different ethnic backgrounds. Each artist's individual style is greatly influenced by his or her cultural experiences. Some painters use black ink only, others use black with just a little color, still others use vibrant color with black ink. Some painters use traditional techniques to paint traditional subjects. Others use those same technical roots to push into new territories, trying new techniques and new subjects. Some paint realistically, others are very abstract. From portraits to landscapes and cityscapes, from flowers to animals, from realistic to abstract, and from black and shades of grey to wild colors, all fall within the broad definition of Sumi-e.

Dragon, by Cecil Uyehara.

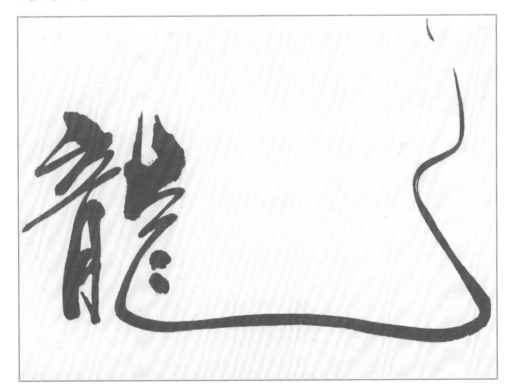

The Brush Dances and the Ink Sings

The Chinese saying "the brush dances and the ink sings" is a perfect description of Sumi-e. Sumi-e is all about energy and spirit. Your aim in Sumi-e is to capture the essence, or spirit, of your subject matter. Don't be concerned with painting exactly what you see. Your experience of your subject and what you feel about it are very important. You may paint realistically if that is your style, but there is always an element of abstraction in Sumi-e. It is said that you have to become your subject to paint it. Try to capture the energy and the life force of the flower, the rock or the tree. This vital force is known as "chi".

Sumi-e is a very spontaneous art form, and you'll probably throw away a lot of paper. The ink flows quickly into the paper and becomes permanent. You can't lift it, move it around or completely cover it. Every stroke shows, there's no correcting or erasing. Because of this, Sumi-e is an art form of great freedom. To enjoy painting, you need to be willing to enjoy the process rather than looking for an immediate, finished product.

Because each stroke shows, every movement of the brush is very important. The vigour and strength in each stroke contribute to the overall life force of the painting. Strong strokes make a vibrant painting, and indecisive strokes make a weak one. Once you are familiar with ink painting, you'll be able to understand and appreciate finished work. You'll see how the brush was held to make each stroke, the direction and speed of the stroke, how much water and ink were on the brush and the hesitancy or strength of the stroke.

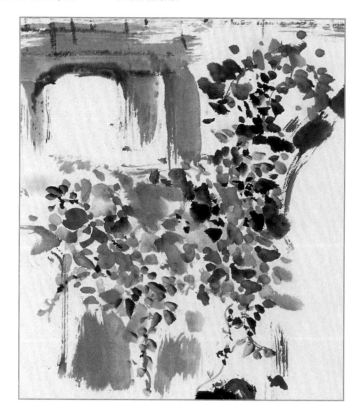

Right and opposite:
Bougainvillea, by Susan Frame.

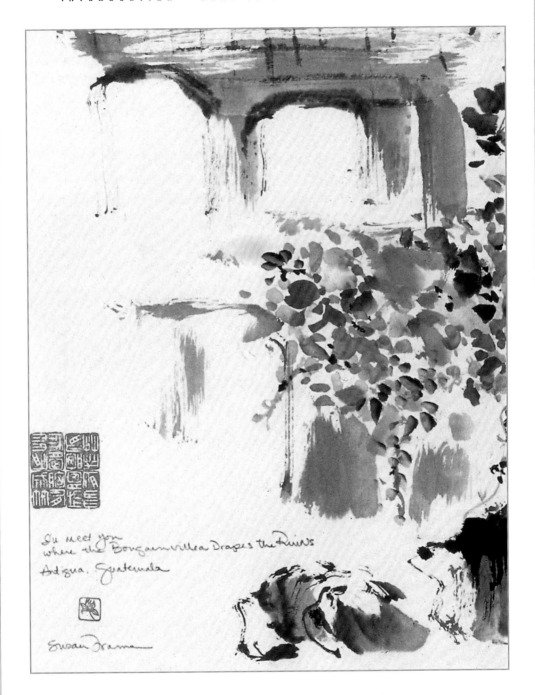

I'll meet you
where the Bougainvillea Drapes the Ruins
Antigua, Guatemala

Susan Frame

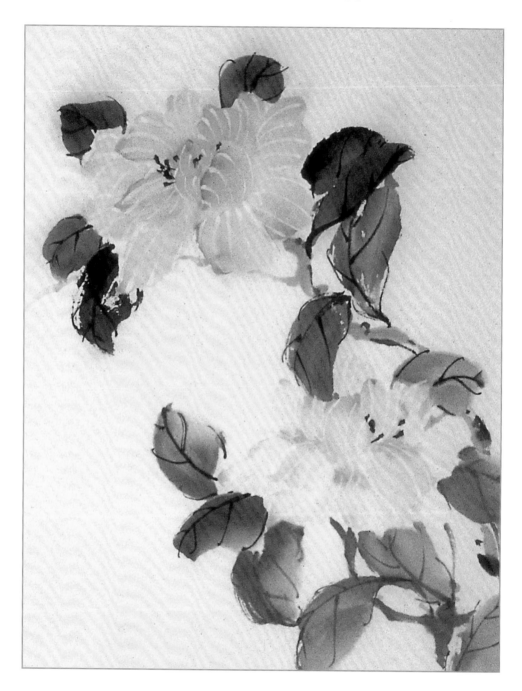

Japanese Ink Painting is the Breeze and the Fragrance of the Flower

It is easy to talk about the need for spirit in a painting, but how do you, the artist, find the life force of your subject? For me, it's a meditative process. It's shutting out the superfluous chatter in my mind and calming myself. Try taking some deep, even breaths. Focus on your subject. Think about it. What is it? What is its essential nature? What does it mean to you? Does it make you feel gentle and soft? Does it make you feel rowdy? Do you feel power or strength? Once you are connected to it, you can interpret it with your brush and ink. You may use slow, soft strokes, wild, excitable strokes or powerful, strong strokes. Just remember: this is more about how it feels inside than how it looks outside.

Below and opposite: Hibiscus, by Susan Frame.

Once you have grasped the spirit of your subject, you can start to simplify it. Simplification is related to how the subject looks, as well as to how it feels. From a spiritual standpoint, we simplify to find the essential in life. This is also true of painting. The simplification of brushwork leads to an aesthetically pleasing painting. For example, imagine lively brushwork with beautiful tones. If more ink is added to those brush strokes, their beauty will be destroyed. Unsuccessful brushwork can sometimes be enhanced with other strokes, but it can never be erased. Correcting usually doesn't help either, because each brush stroke is easily seen. Fewer brush strokes are nearly always better. Your goal is to execute the brush stroke successfully the first time around, as simply as possible.

Black Rose, by Susan Frame.

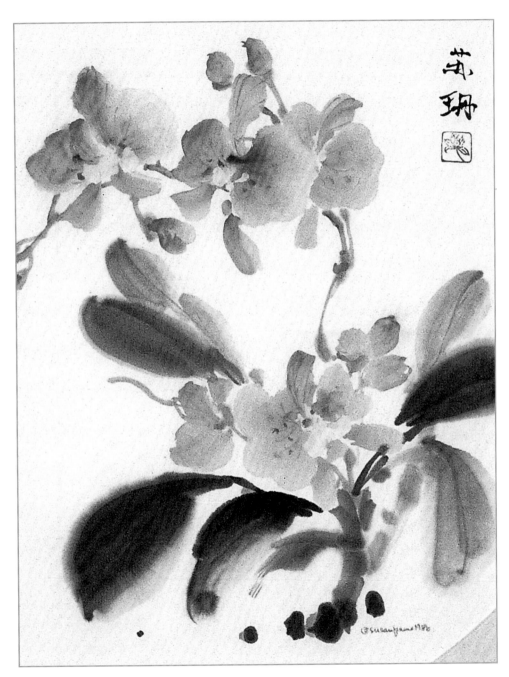

Moth Orchid, by Edith Hollyday.

One of the most obvious characteristics of Sumi-e, simplicity implies using brush strokes sparingly. Paint only the strokes needed to convey your intent. What is your intent? Intent means "what you trying to say". Are you trying to say it's a beautiful flower? It's a rainy day? The birds are happy? The storm is approaching? You don't need to paint every petal and leaf, or all of the feathers on the bird. You don't need to paint every rock in the landscape. It's not even necessary to define the horizon. Leave some details to the viewer. A successful painting is a little ambiguous, it suggests, but doesn't explain. It is open to interpretation.

How do you decide what to include in your painting? One of your duties as the artist is to remove what is unnecessary. Think carefully about your subject. If you plan to paint a rose, begin by imagining it. Picture it in your mind. What physical attributes say "rose"? You'll probably think about the shape of the petals, the overall shape of the flower, the formation of the leaves and, of course, the thorns. All of these characteristics should be included in the painting. You can change the number of petals and their direction. You don't have to include all of the flowers, leaves and branches on the rose bush. Your painting can just be of one flower and a couple of leaves on a branch. That will be enough for an eloquent painting.

Sumi-e is a painting technique, a feeling and a philosophy. It is all of those things together, not one alone. It's the breeze and fragrance of the flower. It's energy and discipline. As a student, you will probably paint your composition, or your individual brush strokes, over and over and over again in your Sumi-e odyssey. Remember that practice is experience. Practise until your skill is automatic. Then you'll be able to quit thinking about it and go on to something else. My success comes when I am able to turn off my thoughts and go into another world, a totally absorbed state of being.

When I'm finished with the last stroke, I sometimes look at the painting and wonder where it came from and how I did it.

For me, painting is a joyful spiritual experience.

The Four Treasures

The Four Treasures

The essential materials used for Sumi-e are known as "the four treasures". These include the ink, the stone, the brush and the paper or silk.

The four treasures: ink, ink stone, brush and paper.

Ink

Ink is available in two forms: stick and liquid. The stick ink is made from pine or oil carbon and glue. The mixture is poured into a mold and allowed to harden. Most sticks have some type of design on them. Sometimes it is a raised design, at other times the design is painted with colors. In the past, gold leaf or precious stones were often embedded, making the ink stick too precious to use!

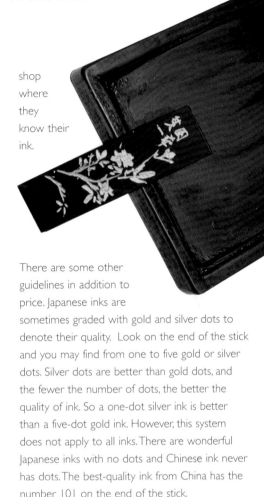

Ink sticks vary in color tone and quality. Tones range from brownish to blueish, depending on the type of carbon used to make the ink. The decision to use a brown or blue tone is a subjective one, based on which you like best. Quality ranges from poor to excellent. Poor-quality ink often has a grainy consistency and needs a lot of grinding before it turns black. Good-quality ink grinds easily, without scraping or scratching, and makes a rich, deep black.

It's difficult for the beginner in the art-supply shop to determine which ink stick is the best: to the novice, they all seem the same. Generally, the price goes up with the quality. This is not always true, however, because it also depends where the ink was made. Do not compare Chinese and Japanese inks on price alone. Chinese inks are generally less expensive than Japanese inks because of the difference in manufacturing costs. Some people can tell the quality of ink by the smell, so if you see someone smelling it, you'll know what they're up to. Since you aren't allowed to try out an ink before you buy it, you are dependent on the storekeeper's advice. So shop where they know their ink.

There are some other guidelines in addition to price. Japanese inks are sometimes graded with gold and silver dots to denote their quality. Look on the end of the stick and you may find from one to five gold or silver dots. Silver dots are better than gold dots, and the fewer the number of dots, the better the quality of ink. So a one-dot silver ink is better than a five-dot gold ink. However, this system does not apply to all inks. There are wonderful Japanese inks with no dots and Chinese ink never has dots. The best-quality ink from China has the number 101 on the end of the stick.

Another option is the readymade bottle of ink. Again, there are a number of manufacturers and various qualities. Some of the manufacturers are unwilling to disclose their secret ingredients and formulae. (This is also true for stick inks.) In general, stay away from India inks because they often contain shellac, which will degrade the hair of your brush. Use inks made in China, Japan or Korea.

There are some differences between using bottled ink and stone-ground ink. For me, the biggest drawback of liquid ink is that it skips that wonderful grinding process. I also think that bottled ink is a little less subtle than the ground ink, but that is something you'll only be able to tell after a lot of practice with both kinds of ink. There is also a difference in the way that they interact with the paper and the water. Ground inks are often more permanent. Once applied to the painting surface, they stay in place. Bottled inks are a little more fugitive, that is, they move more before they're dry, especially if water is introduced. However, you can always add a little more glue if needed. There are some contemporary techniques that are more easily done with liquid inks because of their ability to move. Once you're familiar with both kinds of ink, you can choose the one most applicable to your technique.

Ink Stone

Ink stones provide the surface on which to grind your ink. They are usually made from slate, although beginner stones may be made of a clay-composite material. The grinding surface needs to be smooth enough to make a particle-free liquid, but it also needs some "tooth" so that it can actually grind. The best stones feel smooth and almost "soft" to the touch. Some stones are beautifully carved and some have covers made of lacquered wood. Some are round, some square and some irregular. The stone most commonly found in art-supply shops is rectangular in shape, with a flat surface that slopes to a small well.

To make ink, put a little water into the stone. Using the stick, pull water out of the well and grind the stick and water on the flat surface of the stone. Use a circular motion and exert a little pressure. Pull more water from the well and grind until the ink is very dark and has a creamlike consistency. The length of time that it takes to get a nice black depends on the quality of the ink and how much of it you're making. I think grinding ink is a wonderful process. There's a saying that while grinding ink, you "still your heart before you begin painting".

Grinding ink is very meditative; it's a way to become in tune with your materials and to settle down. You can think about your subject, think about your brush and paints; forget about your work schedule and your problems. Grind in a circular motion and empty your mind.

To care for your ink stone, wash it with water after every use. Do not use soap. Don't let ink residue build up on it from one painting session to another, and don't re-use old ink. Wrap the stone carefully when you travel, because it can chip and break.

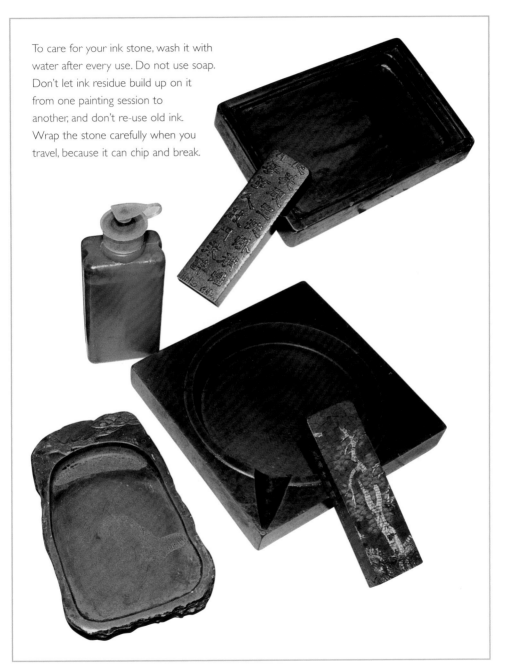

Various stones with sticks.

Brush

Ah, the beauty of brushes! The first brush was invented in China more than 2000 years ago. Today, brushes come in different sizes, from very small to huge. Some giant brushes are as big as a floor mop. Most brushes have bamboo handles with bone ferrules. The brush itself is made from animal hair. Almost any kind of animal hair can be used. Each type of hair responds to the touch of the paper and the flow of the ink in a specific way. The most common hairs used for brushes include sheep, horse, sable, weasel and rabbit. I've also seen brushes made from chicken feathers, boar, wildcat, bear, moose and even rat whiskers.

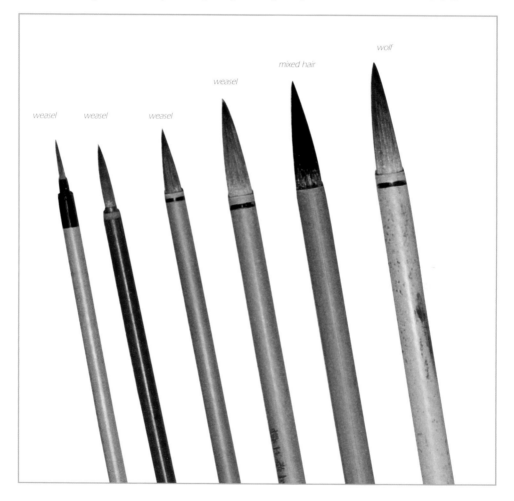

wolf

mixed hair

weasel

weasel weasel weasel

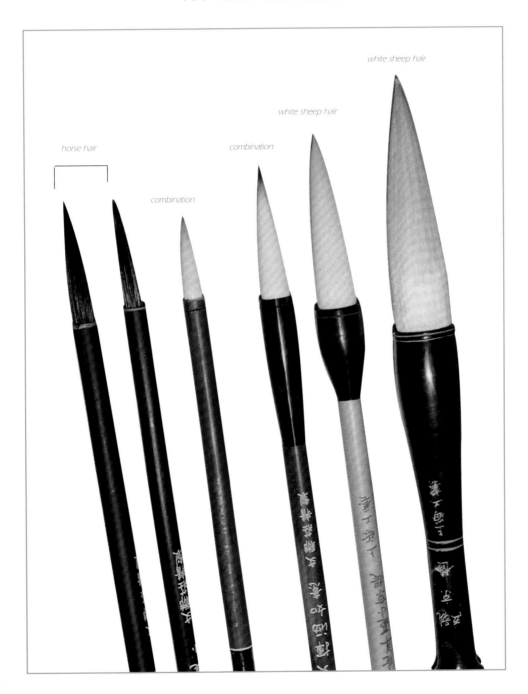

horse hair

combination

combination

white sheep hair

white sheep hair

In general, there are two types of brush: brown- or red-haired (hard) brushes and white-haired (soft) brushes. The brown-haired brushes are made from sable, weasel, deer, horse and other brown-haired creatures. The main characteristic of all brown-haired brushes is the ability to respond. A good-quality brown-haired brush has good bounce capabilities. You can push down and lift up on the tip of the brush and it will return to its original shape. Some brown-haired brushes are also very good for textural effects.

White-haired brushes are made from sheep or rabbit hair, and typically do not have that bounce capability. Because of this, manipulation is a little more difficult for the beginner. Their main characteristic is holding power. A white-haired brush holds more liquid and, in a size-to-size comparison, will go much further than a brown-haired brush before running out of ink. White-haired brushes are capable of making very full, soft brush strokes.

You will also find combination brushes. These brushes contain different kinds of hair and therefore have a combination of characteristics.

Typically, hard hair is in the center of the brush, surrounded by softer, more absorbent, hair. Sometimes, however, the harder hairs surround the softer hairs or one type of hard hair surrounds another type of hard hair.

hake (sheep)

Various "used" brushes.

combination

combination

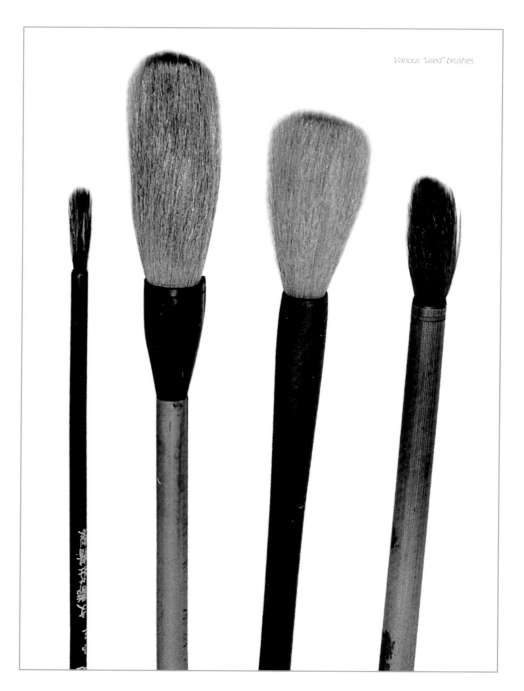

Various "used" brushes.

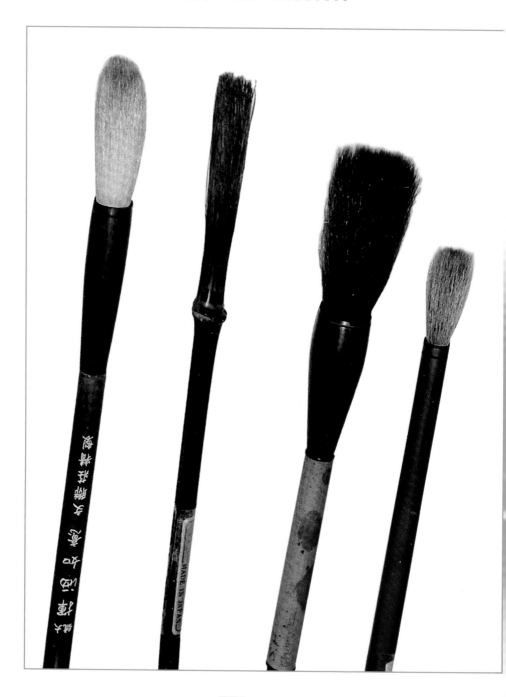

The brushes that I recommend, showing a new,
starched brush next to a used brush.
The large brushes are "Orchid Bamboo",
the smaller are "Leaf Vein".

Various 'used' brushes.

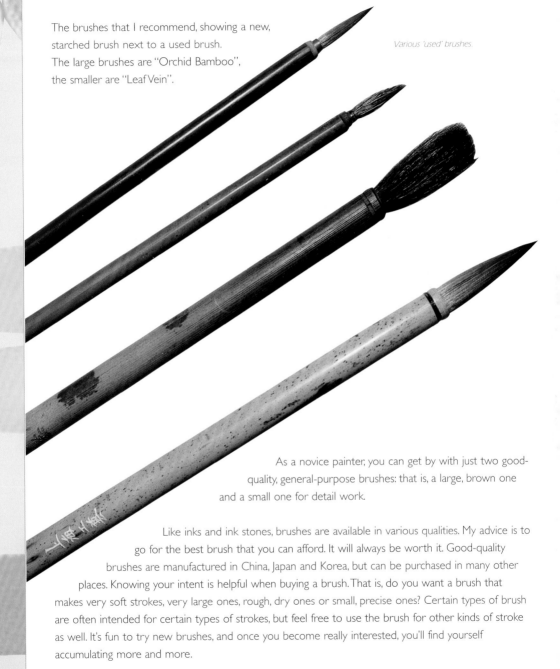

As a novice painter, you can get by with just two good-
quality, general-purpose brushes: that is, a large, brown one
and a small one for detail work.

Like inks and ink stones, brushes are available in various qualities. My advice is to
go for the best brush that you can afford. It will always be worth it. Good-quality
brushes are manufactured in China, Japan and Korea, but can be purchased in many other
places. Knowing your intent is helpful when buying a brush. That is, do you want a brush that
makes very soft strokes, very large ones, rough, dry ones or small, precise ones? Certain types of brush
are often intended for certain types of strokes, but feel free to use the brush for other kinds of stroke
as well. It's fun to try new brushes, and once you become really interested, you'll find yourself
accumulating more and more.

To care for your brushes, always rinse them
with cool water when you've finished
painting. Don't use soap. Remove the excess
water by squeezing the brush with your
fingers or by wrapping it in a towel and gently
squeezing it. After all of the excess water has
been removed, form the hairs into a point. If
your brush has a loop on the end, hang it up
to dry. If not, lay the brush handle flat on the
table, with the hairs lying off the edge of the
table.

To facilitate drying, air should circulate around
the brush tip. Never dry the brush by setting
it in a container with the handle pointing
downwards and the hairs upwards. If you do,
water from the tip will run into the handle
and can cause the tip to become unglued.
(You can store the brush that way, but
don't dry it like that.)

When you travel with your brushes,
wrap them for protection. You can buy
bamboo mats that are specifically
designed as brush-wrappers. Some
people use bamboo place mats and
add some elastic to hold the brushes
in place. Even a towel or newspaper
will work. Just be sure to unwrap
your brushes and
to expose them
to air to dry.

*Brushes shown both hanging up and
lying off the edge of a table.*

Paper

The first paper was made in China in A.D. 105 as a by-product of silk production. Leftover cocoons, fibers and threads were processed into silk batting for clothing, bedding and so on. After the batting was lifted from the drying screen, a thin sheet of short silk fibers remained. This was the first paper.

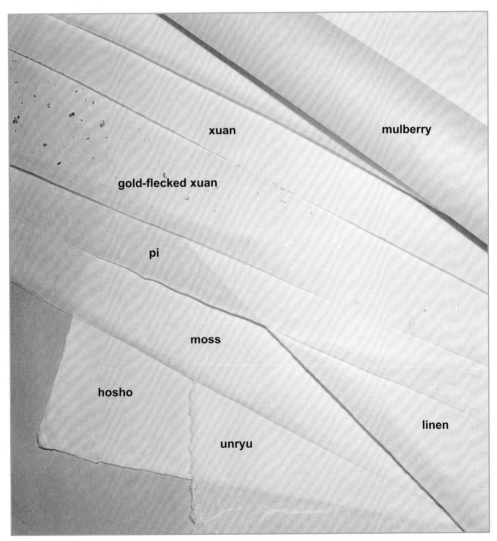

Various papers.

Buddhist monks introduced paper to Japan, and today both China and Japan produce beautiful papers specifically for ink painting. Most papers suitable for Sumi-e techniques are made in Asia, although you can also find some made in other places.

In the West, Sumi-e paper is known as "rice paper", although it is not made from rice. Papers are made from a variety of plant materials: sandalwood, bamboo, mulberry, cotton and linen. Most manufacturers keep the exact formulae of their papers secret. The paper most often used for Sumi-e is unsized, absorbent paper. Unsized means that there is no glue or starch added to impede the absorbency when the paper is made. Because it is unsized, the ink and water flow freely into the paper.

Unsized papers handle the ink and water differently, depending on their type and thickness. Thin paper is very lightweight, absorbent and tears easily. It is the least controllable of the papers because the ink and water flow out freely from the brush stroke. The thicker the paper, the less the ink flows out, away from the stroke. Because it's thicker, the ink has more layers to flow through and therefore

Below and opposite: Wet ink on unsized and sized papers.

doesn't flow out as much. I think of the thicker papers as being thirstier because they drink up the liquid in the brush faster than thinner papers do.

Some painters also use sized paper or semi-sized paper. The flow of the ink and water are slowed on a sized paper. Because of that, small, detailed strokes are sometimes more easily executed. Also, instead of flowing into the paper, the liquid forms puddles that can be manipulated for other kinds of effect. A major characteristic of sized paper is its inability to keep tones of ink and individual brush strokes separate. Shades of ink will all blend together and brush strokes will appear much flatter. Consequently, layering techniques are often used on sized paper.

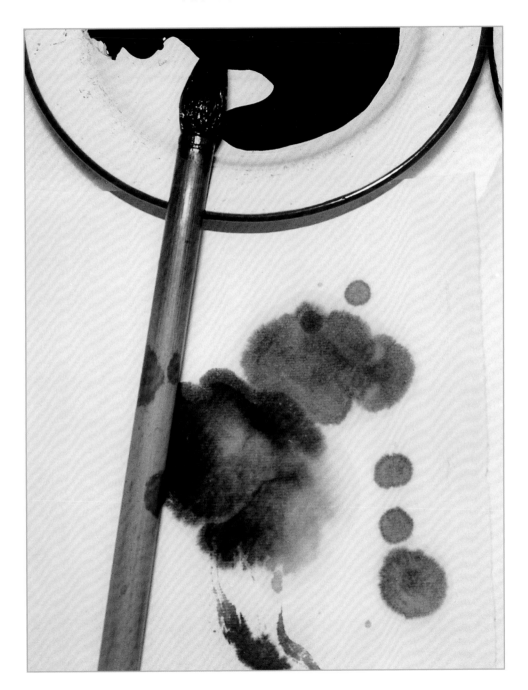

The best Sumi-e papers are handmade, but you can also find inexpensive, machine-made practice papers in small sheets, rolls or pads. Chinese papers are standard sizes, the smallest being 27 × 54 in. You can divide this paper into pieces for smaller paintings.

Some examples of paper suitable for Sumi-e are xuan (pronounced "shuen"), from China, and gasenshi, from Japan. Japan also produces a beautiful paper called hosho. It is very white, thick and cotton-like, almost like fabric. You can also find decorative papers that are suitable for Sumi-e. For example, xuan paper with gold-leaf flecks or thin, translucent paper with long, silky, white fibers called unryu.

Effects of ink on unsized paper.

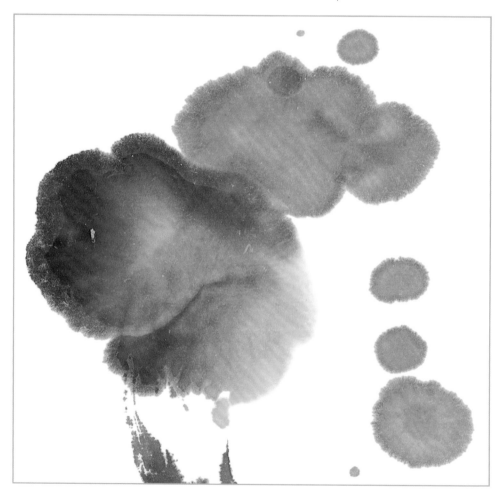

Effects of ink on sized paper.

Experiment with different papers to find ones that you like. The choice of paper is a subjective one, based on your personal preferences. As you try different techniques and different subjects, you'll discover that the kind of paper used influences the result.

Tip

When you try a new kind of paper, write its name in pencil on the edge so that you'll know what it is when you need more.

Color

Many Sumi-e painters choose to use black ink, with no color, for their paintings. It is said that you can see the colors of the rainbow in black. This is because the artist uses many different shades of black, from very black to very light gray, in the painting. It's easy to imagine the painting in color when the tones are so rich and varied.

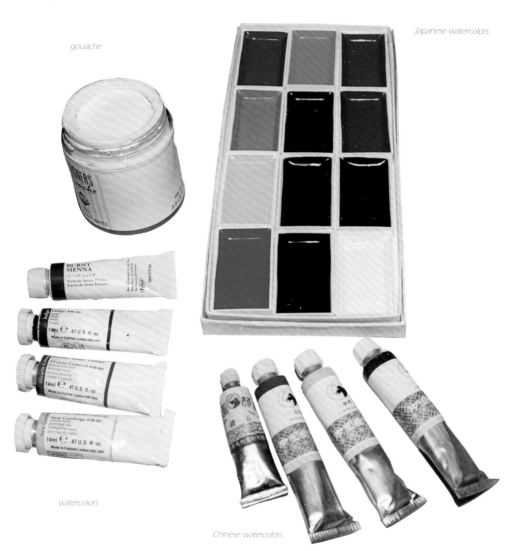

gouache

Japanese watercolors

watercolors

Chinese watercolors

If you like color, however, at some point you'll want to use it in your painting. There are a number of types of colored paint that can be used. Traditional Japanese colors come in transparent sticks or semi-opaque cakes.

Traditional Chinese colors are available in small, transparent chips made from vegetable matter, tubes similar to watercolors and opaque powders made from minerals.

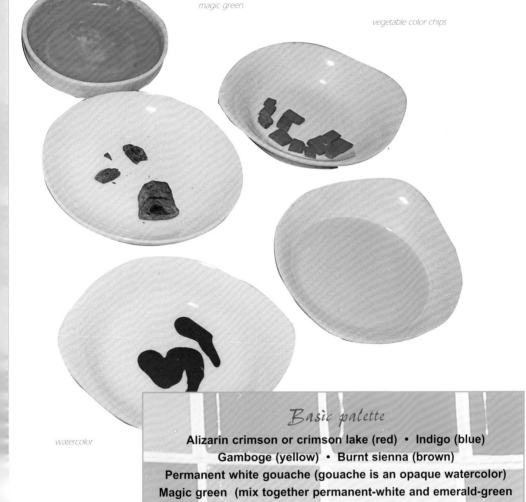

magic green

vegetable color chips

watercolor

Basic palette

Alizarin crimson or crimson lake (red) • Indigo (blue)
Gamboge (yellow) • Burnt sienna (brown)
Permanent white gouache (gouache is an opaque watercolor)
Magic green (mix together permanent-white and emerald-green
gouache)

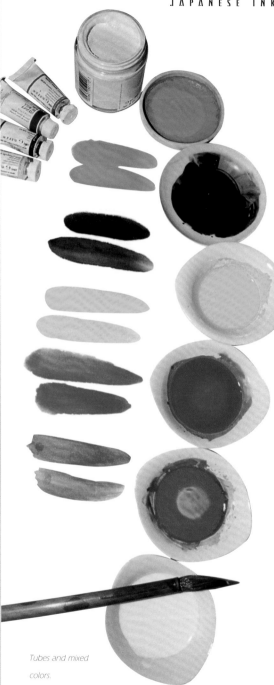

Tubes and mixed colors.

Key points

1. Ink is available as a stick or liquid. Either is acceptable. Don't use India ink because it contains shellac.

2. To make ink, grind the ink stick with water on the ink stone.

3. Brown-hair brushes are very responsive and have bounce.

4. White-hair brushes are very soft and hold a lot of ink and water.

5. Combination brushes usually have both of the above qualities.

6. Only two brushes are necessary for the novice student: a large, brown-hair brush and a small, detail brush.

7. Don't use soap to clean your brushes. Always allow your brush to air-dry either by hanging it tip downwards or by laying it flat, with the hair off the table.

8. Unsized, absorbent paper is usually used for Sumi-e.

9. There are many types of paper and the choice is subjective. Try them out to see which you like.

10. Colors are available as sticks, powders, cakes and tubes. The demonstrations in this book use Western tube watercolors.

...llea Drapes the Ruins

Prepare Your Workspace

Before you begin painting, you'll need to set up your painting area. You will be painting flat on the table, so spread out a protective table-covering. Use either felt (preferably white) or a few sheets of newspaper. The felt or newspaper prevents the water and ink from puddling on the table and going back into the rice paper. If you're right-handed, most of your painting materials should be on the right side of your paper; if you're left-handed, put them on the left. Furthest away is the water container for rinsing your brush, then your stone and plates of ink. The blotting towel should be directly next to your paper. Be sure to leave room to lay your brush down when you're not using it.

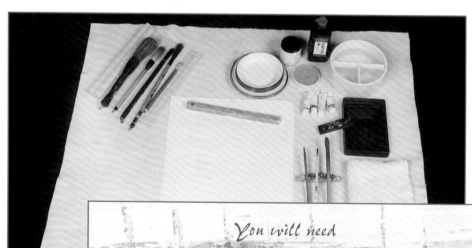

A studio set-up, showing how to arrange painting materials, including brush rest.

You will need

Brushes • Ink (either liquid or stick) • Ink stone (if using stick ink)
Colors (optional) • Water container for rinsing brushes • (2 or 3 if using color)
Small plates for mixing colors, preferably white (2 if working in black ink only,
5 or more if working in color) • Paper – practice Sumi-e paper, xuan paper,
mulberry paper, etc. • White felt or newspaper to put under your painting
Small towel or paper towel to blot your brush • Paperweight (optional, but
useful)

Preparing to paint

Step 1

New brushes are stiff with sizing, so soak them in cool water until they're soft and pliable. (Don't ever put the cap back on because it will break the brush hairs. It's for shipping protection only.)

Step 2

Tear the paper to size. The easy way to do this is to crease the paper, then run a wet brush along the folded edge of the paper. It will pull apart easily.

Step 3

If you're using an ink stone and stick, grind the ink with water in a circular motion on the flat part of the stone. Refresh your spirit as you grind your ink. After a few minutes, dip in your brush and try it out on a piece of paper. When your ink is thick and dark black, it's ready. We'll call thi dark ink. Blot your ink stick on a cloth or paper towel when you finish grinding to prevent it from cracking.

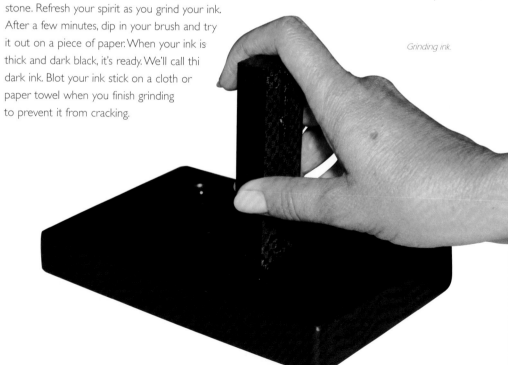

Grinding ink.

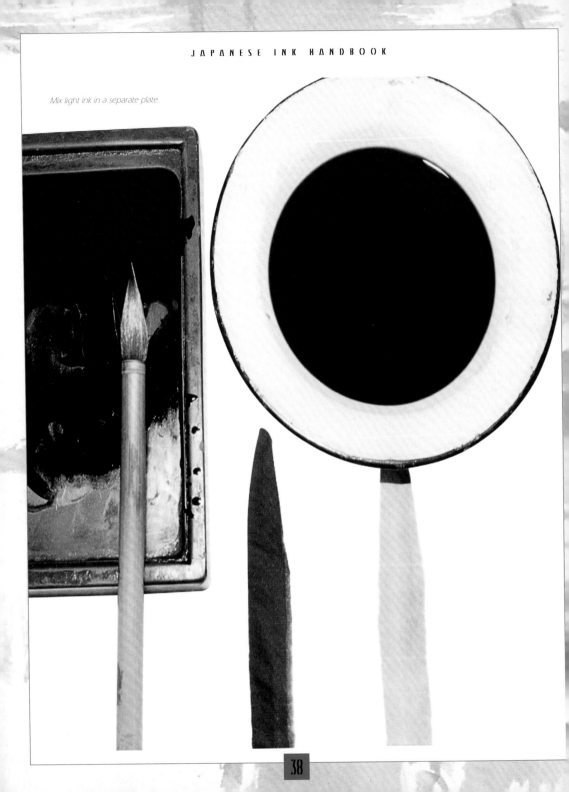

Mix light ink in a separate plate.

Step 4

Alternatively, if you're using liquid ink, pour a small amount of it into one of your plates. No grinding is necessary. We'll also call the ink in this plate dark ink.

Step 5

In a separate plate, make a lighter shade of ink by mixing a few small brushfuls of dark ink with water. Mix it well. Try it out on your paper. It should be a middle shade of gray, drastically lighter in color than your dark ink, but also much darker than clear water. We'll call this light ink.

Step 6

You can sit or stand when you paint. Do what's comfortable. I usually paint standing up because I'm much more energized that way. I move around when I paint, and my arms and body have full movement when I'm standing.

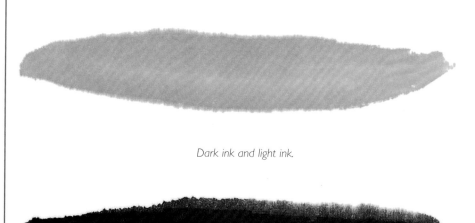

Dark ink and light ink.

How to Hold the Brush

Let's start with the basic technique of how to hold the brush. Hold it upright, with your thumb on one side and your index and middle fingers on the other side. Your ring finger goes behind the brush, with the fingernail flush to the brush. It's much like holding chopsticks, so if you already know how to do that, you'll have no problem. The advantage of holding your brush

like this is the great range of movement that it allows. You have a 360° range of movement with your fingers, your wrist and your arm, all of which you will use when you paint. There's also another advantage.

Since this way of holding a brush is different from your usual way of holding a pen or pencil, you'll develop new habits for painting rather than using old writing habits.

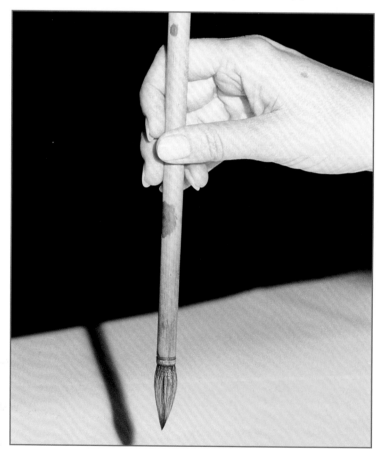

How to hold a brush correctly.

Brush-loading

Sumi-e is an art form of simplicity, and the ink is dramatic and eloquent. The dark and light ink tones represent the colors and the spirit of both the outside and inside worlds. There is a saying that "black ink is black, yet not black". Brush strokes are economical, containing both light and dark shades. The technique of charging the brush with ink is called brush-loading.

This brush-loading technique is the basis of all brush strokes. It often takes a lot of practice to get it right, so be patient and don't be frustrated if you don't get it on the first try. Some of my students think it takes a lifetime, but they all enjoy the process.

First, rinse your brush with clear water. Then pat it on a towel to take some of the excess water off. Think of it this way: your brush is totally saturated with water and you need to make room for some ink. So you blot it a little. If you hold the brush in the air, with the tip pointing downwards, it shouldn't be so wet that it drips water. It also shouldn't be so dry that the hairs separate.

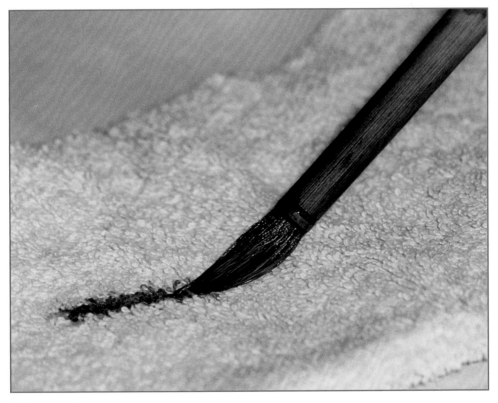

Blotting on a towel.

Loading three-quarters full.

Dip the brush in your light-ink plate and fill it up about three-quarters full. Then blot it again to take off the excess.

Finally, dip the tip in the dark ink. You control the darkness of your brush stroke by the amount of ink that you put on the brush tip. Try adding just a tiny bit of dark to the tip, now pull the brush across the paper. You can see that the brush stroke has just a little bit of black, with a lot of gray. Try adding a little more dark ink to the tip and pull your brush across the paper. You'll see that the stroke is a little darker. Add even more dark ink, pull across the paper and you have a fairly dark stroke. The darkness of the stroke is totally controlled by you, and by the amount of dark ink that you add to the tip of your brush. There will be times when you'll need a very dark stroke, but you will never want a gray stroke with no tonal variation. A stroke with no tonal variation shows a lack of brush-loading skill.

It's a good idea to rinse your brush after each stroke when you're learning to paint. That way you can see exactly what you're putting on the brush and what it's doing on the paper. When you're comfortable with brush-loading, you probably won't rinse your brush as frequently.

Loading the tip.

Wet and Dry, Fast and Slow Strokes

Now it's time to try some more strokes. First off, you need to play. Touch the brush to the paper to see the reaction. Notice how the ink is absorbed and how it spreads on the paper. This spread is directly related to how wet your brush is (how much liquid is on the brush) and the speed with which your brush moves across the paper. You can do some practice strokes to get the idea.

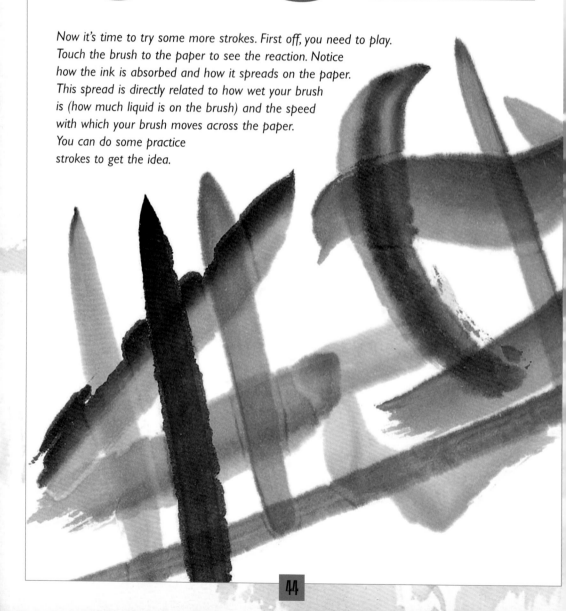

Exercise 1

First, load the brush with both light and dark ink, using the basic brush-loading technique without blotting much water or ink off the brush. Then, holding your brush in the upright position, pull it across your paper slowly, very slowly. Then pull it across your paper quickly, very quickly. Notice how the seepage of ink varies with the speed of the stroke. Using a wet brush, moving very slowly, the paper absorbs a lot of the liquid and there's a great deal of ink bleed. When you speed up and pull the brush more quickly, less liquid is absorbed, so there's less bleed. You'll also notice more texture with a faster brush.

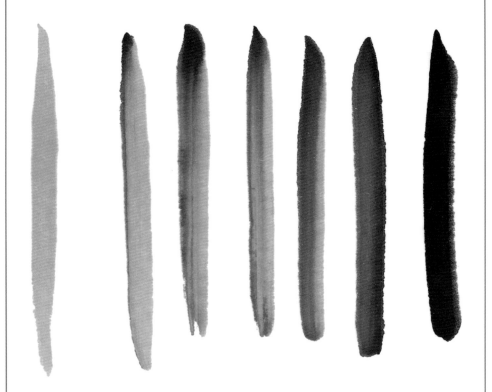

Brush strokes showing tonal gradation. Use just a little dark ink on the tip for lighter strokes and more dark ink on the tip for darker strokes.

Exercise 2

Now you can try the same exercise with a dryer brush. Begin by loading your brush with light and dark ink, again using the basic brush-loading technique. This time, blot your brush much more thoroughly after the clear water, after the light ink and after the dark ink. Then pull your brush across the page very slowly. Notice that a dry brush, when moved very slowly, produces a stroke that looks wet. The slow speed allows the ink and water to bleed into the paper. Now pull your brush across the page quickly, and you'll see that your brush stroke looks very dry and is hardly absorbed.

If you do this exercise at different speeds, with various levels of wet and dry, you will learn the basics of brush control. Be sure to have tonal variation in every stroke.

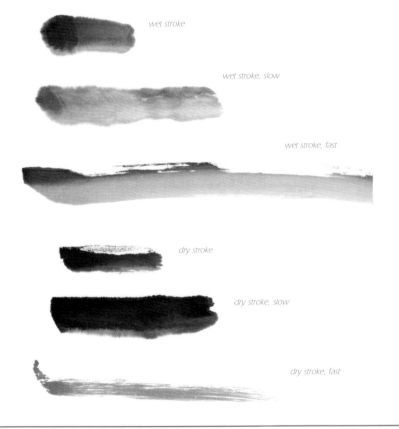

wet stroke

wet stroke, slow

wet stroke, fast

dry stroke

dry stroke, slow

dry stroke, fast

Exercise 3

Paint some lines across the page and then paint more lines in the opposite direction on top of your first lines. Do you see how the bottom strokes show through the top strokes? There is no way to correct your brushwork because each stroke shows. There's also no way to erase it because the ink is permanent and the paper fragile. You can see that too much stroke overlap in the painting will often destroy its simplicity.

There is no way to correct brushwork because bottom strokes show through top strokes.

Four Basic
Brush Strokes

There are four basic strokes and many variations. You will use these strokes all of the time, so learn them well. As you practise your strokes and tussle with your brush and ink, remember that your aim is to gain complete control of the materials and the techniques. Once you have succeeded, you can abandon control and paint freely, without hesitation. Load your brush with light and dark ink, using the basic brush-loading technique, and we'll begin.

Pulling Stroke

Holding your brush straight upward, perpendicular to the paper, pull it across the paper. Use your whole arm as you move, not just your wrist. If you angle the brush a bit and pull it across the paper, it's still a pulling stroke. Notice that your hand leads the way on the pulling stroke and the brush tip follows. Sometimes this pulling stroke is called the "central brush stroke" because the ink is coming from the central portion of the brush. You'll use this pulling stroke for many subjects: tree branches, flower stems, leaf veins, cat whiskers, water movements and bird beaks, to name just a few.

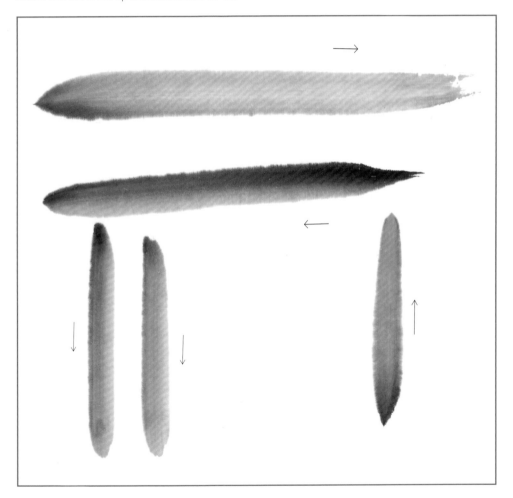

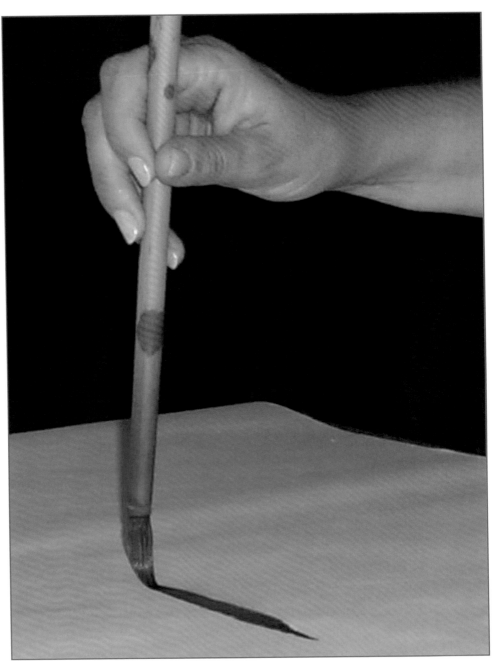

Hand, arm and brush position: pulling stroke.

Pressure Stroke

The pressure stroke is really a variation of the pulling stroke, but it's so important that we're calling it a separate stroke.

Holding your brush straight upward, perpendicular to the paper, pull it across the paper. This time, as you pull, push down on the tip slightly and lift up slightly, push down and lift up to create thin and thick lines. Your brush must be pointing straight upward to produce pressure. If it's angled, there's no way to push or lift.

Your push/lift movement should be smooth, not jerky, with consistent speed. Go slowly at first, and keep your arm steady. This is a whole arm movement, not just a wrist or finger movement. If you're doing it correctly, your arm moves and the brush tip skates across the paper. If you're pushing and lifting but you're getting fat blobs, you may be pushing too hard or the brush may be too wet. Use just the tip of your brush, not the whole brush. Also, if you're getting blobs instead of delicate lines, your speed may be inconsistent. Slow down and concentrate on working at an even speed. A brown-haired brush, or a combination brush, is ideal for this stroke. A brush with body and bounce will respond to pressure and retain its shape, making it easier for you to do the stroke. Practise this stroke in all directions across your page. Also practise it in circles.

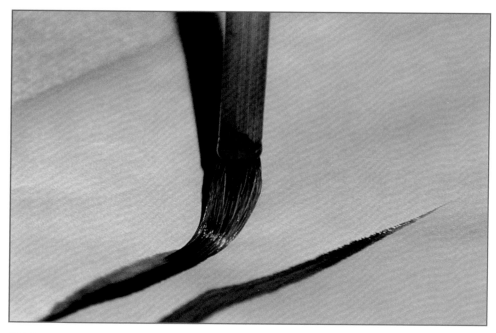

Brush tip on paper.

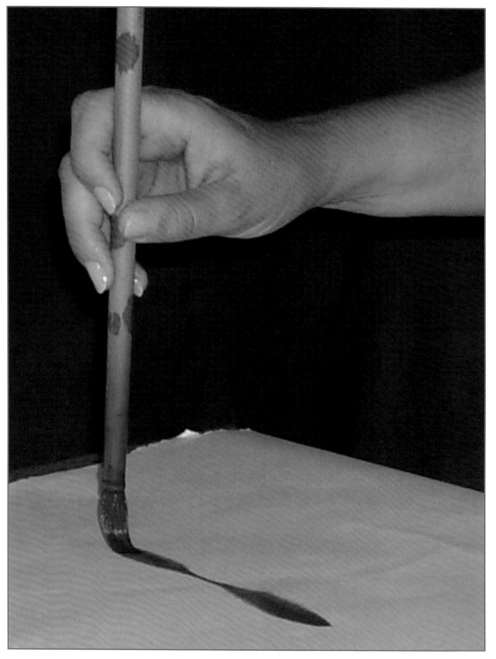

Hand, arm and brush position: pressure stroke.

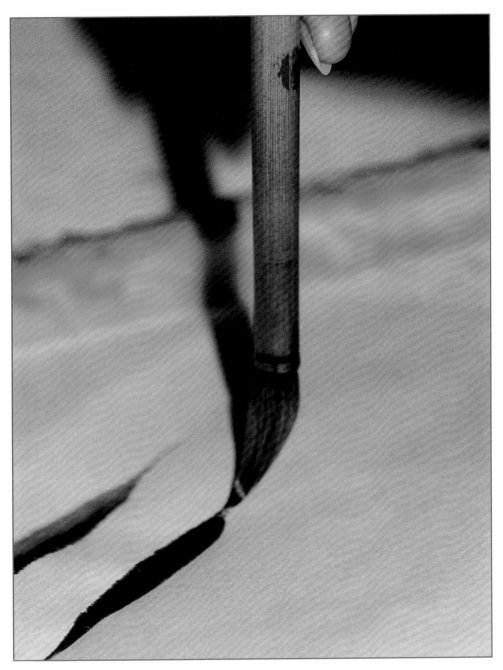

Lifting brush for tail.

As you're practising this stroke, end it by lifting the brush slowly to create a point. Again, your speed needs to be consistent and your lift needs to be gradual. There's a follow-through to this stroke. As you pull and lift the brush, don't allow yourself to stop abruptly at the end. Keep going until your brush is totally off the paper and you'll get a nice point.

You'll use this pressure stroke for all kinds of subjects, such as bamboo leaves, willow leaves, grasses, cattails, irises and chrysanthemums.

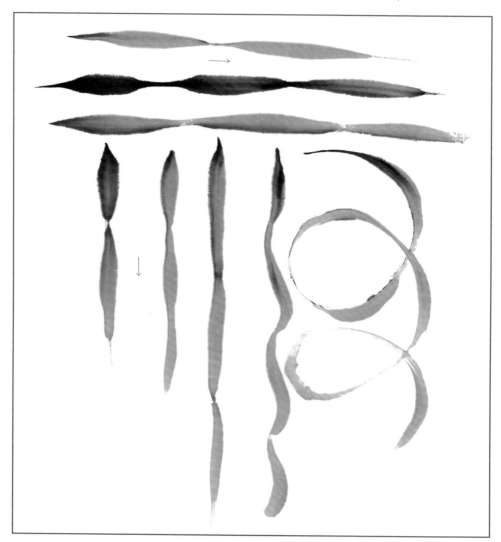

Side Stroke

The third stroke to learn is the side stroke. Hold the brush upright, then tilt the handle until it is about 45° to the paper. Now drag the brush across the paper so that the ink comes from the side of the brush. This is not the same as a pulling stroke with an angled brush. Notice the difference in how the brush is held. (See photo p56.)

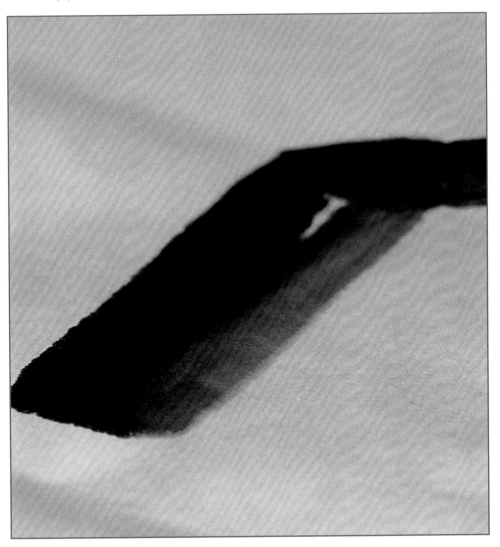

Side stroke: the side of brush moves across the paper.

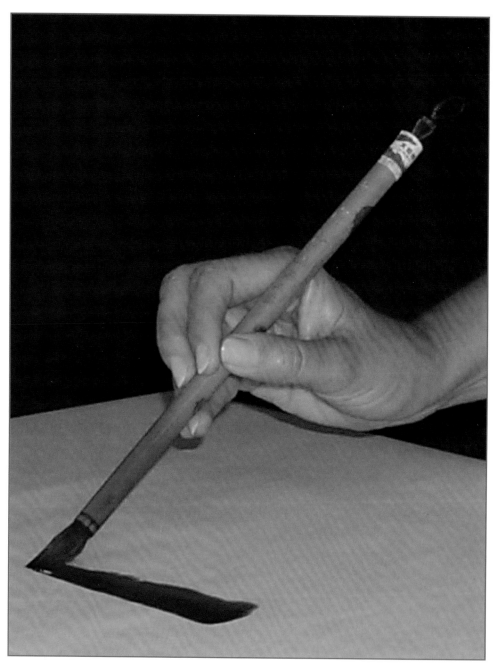

Hand and brush position: horizontal side stroke.

A true side stroke will feel a little awkward at first because your hand twists. Try making a side stroke that goes horizontally across your page. If you're doing it correctly, the brush tip points either to the top or bottom of your page, while the body of the brush moves sideways across the paper.

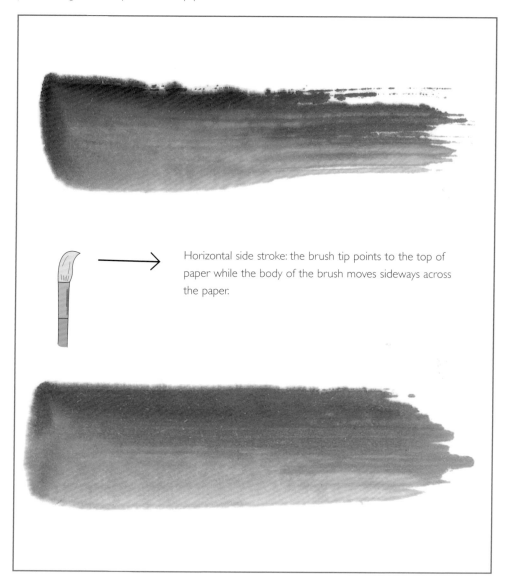

Horizontal side stroke: the brush tip points to the top of paper while the body of the brush moves sideways across the paper.

Vertical side stroke: the brush tip points to the left side of the paper while the body of the brush moves upward.

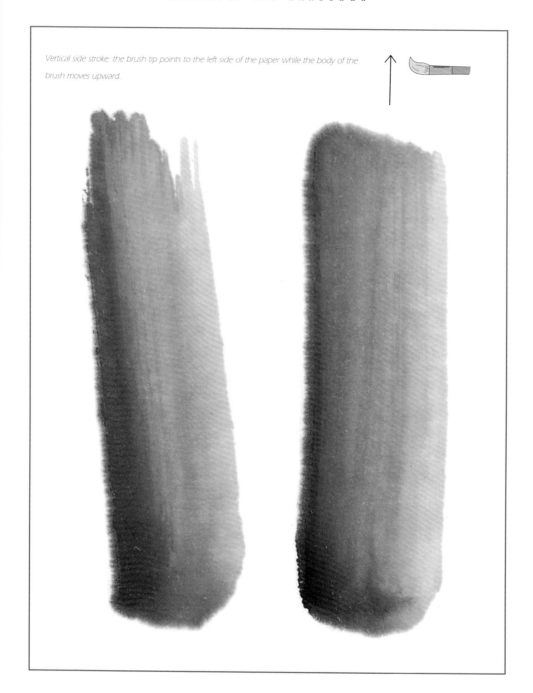

Now try making a side stroke that goes vertically up or down your paper. If you're right-handed, the tip of your brush points to the left side of the paper and the body of the brush moves up or down the paper. If you're left-handed, the tip of your brush points to the right side of the paper while the body of the brush moves up or down.

You'll use the side stroke for bamboo stalks, flower petals, all kinds of leaves, clouds and mountain tops. You'll also use it in combination with the pulling stroke for tree trunks and branches.

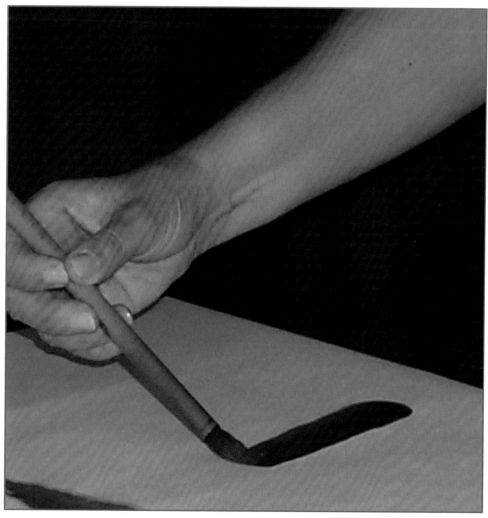

Vertical side stroke.

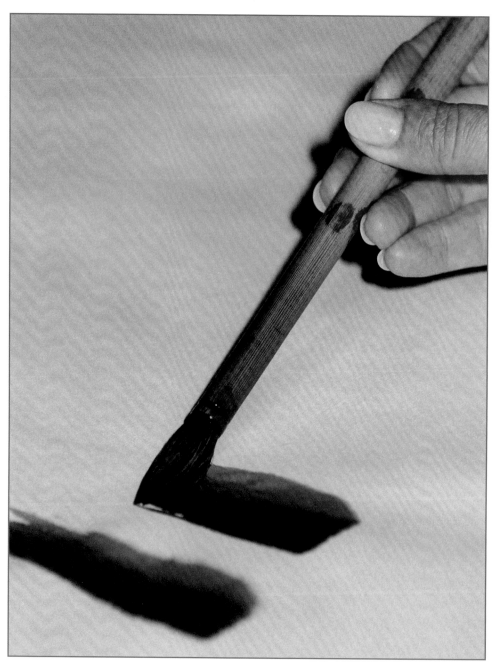

Hand and brush position: vertical side stroke.

Smooshing Stroke

Another important stroke to master is what I call the "smooshing" stroke. Hold the brush straight upward, as if you're doing a pulling stroke, then relax the handle so that it tilts a bit. Push down on the brush so that both the tip and heel are in contact with the paper. Now twist the heel of the brush to the side. I call it the "smooshing" stroke because you "smoosh" the heel of the brush into the paper. It's a stroke that has much more heel action than tip action, and the heel moves much more than the tip does. Be careful not to push the heel too hard or your paper will tear. You'll use this stroke for a number of flowers, including the peony and plum blossom, as well as in combination with other strokes.

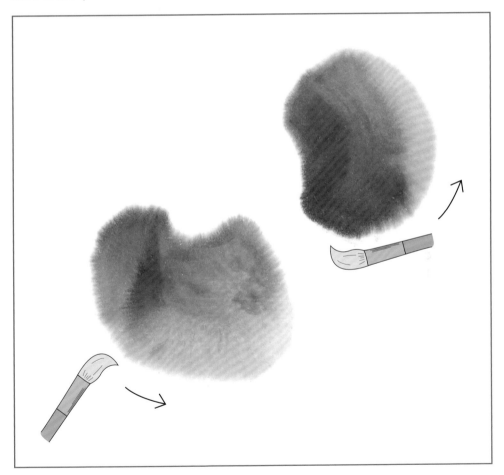

Now that you've learned the four basic techniques, you should know that there are many other strokes as well. They're mostly combinations, or variations, of the strokes that you've just learned. In Asia, poetic names describe every stroke, such as "rat tail", "nail head", "stag horn", "fish bone" and "fish tail". For our purposes, the names are unimportant. I encourage you to make up your own strokes.

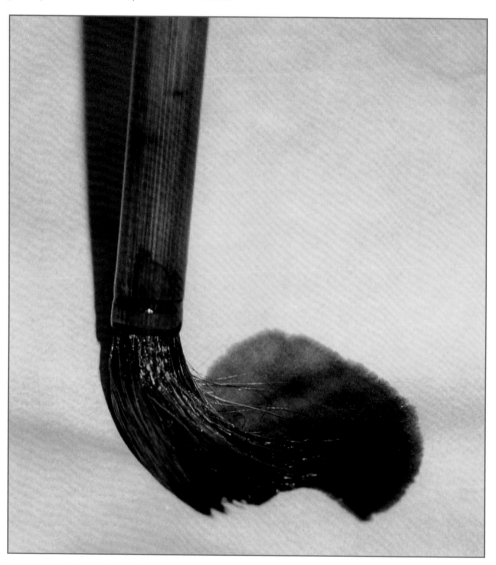

Brush position for the smooshing stroke.

Don't wait for someone to tell you "Do the stroke this way, in that direction" because you may discover a different way that works very well for you. Move your brush around in various directions. Push, squiggle, scrunch, scratch and glide it across your paper. Whatever you do with your brush on the paper is acceptable, and it's especially wonderful if it serves your purpose.

Key Points

1. Load the brush with water, light ink and dark ink in that order. Blot it to remove excess liquid.

2. A wet brush and a dry brush create different kinds of stroke on the paper.

3. A fast stroke and a slow stroke make different effects on the paper.

4. There is no way to cover up or correct brush strokes.

5. A pulling stroke is done with an upright brush and the ink flows from the tip.

6. A pressure stroke is done by pushing down and lifting up on the tip of the brush to create thin and thick lines.

7. A side stroke is done by laying the brush down and dragging the side of the brush across the paper.

8. A smooshing stroke is done by pushing down on the tip and twisting the heel of the brush.

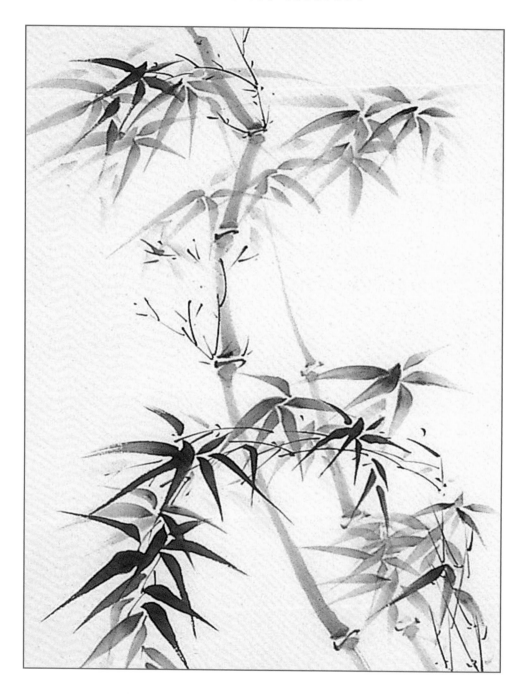

The Value of a Sketchbook

You need to know your subject well to paint it. If you've never seen a rose, it will be difficult to paint its life force. Study the real thing. Go outside and walk around in the garden. Explore the river's path. Examine the flowers in the vase. Don't rely only on books for your knowledge because there is no substitute for experience.

Pages From a Sketchbook

As you observe your subject, fill your sketchbook with useful information. Sketch different angles and viewpoints, record details of anatomy and notes about color. Remember that your sketches aren't intended to be works of art. They're reference material. They'll refresh your memory when you need it or transport you back to that place of inspiration. Your sketches may be indecipherable to everyone but you. They may be filled with lines and dots, as well as written notes. Everything is acceptable in a sketchbook.

Up the shore from Naniboujou Lodge, Lake Superior, Minnesota.

The pathway to strong brushwork can be difficult, and starting out on your own is probably overwhelming, so I'll provide some step-by-step projects for you to follow. If you work through these projects, I hope that by the end you'll be able to look at that flower in your yard and work out your own strokes with which to paint it.

"Brother Cadfael" rose, Van Dusen Botanical Gardens, Vancouver, B.C.

The Four Gentlemen

The first four demonstrations are known as the "four gentlemen". The orchid, bamboo, plum blossom and chrysanthemum each symbolize a season, as well as a "gentlemanly" personality trait, a guideline for upright living during Confucius's time. These four subjects are the cornerstones of Sumi-e, and the strokes used for them will prepare you for most other subjects. Because they're the basic Sumi-e subjects, black ink only, no color, will be used in the demonstrations. That way you'll really be able to see the strokes and shades of ink without being distracted by color.

Painting the Wild Orchid

The wild orchid is the symbol of spring and personifies grace. Therefore your goal is to paint flowing strokes that show the graceful movement of the flowers and leaves.

First, tear the paper to whatever size you intend to use and lay it flat in front of you on top of an absorbent surface (felt or newspaper). Now make both dark and light ink. Next, rinse your large brush thoroughly and blot off the excess water. Load your brush three-quarters full of light ink, blot the brush and load the tip with dark ink.

Preparation

1. Load the brush with water, light ink and dark ink.
2. Using pressure strokes, paint long, graceful leaves with tonal variation.
3. With short pressure strokes, paint the flower petals. They should be tipped with black ink.
4. Paint the flower stem and attach the flowers to it.

Wild Orchid, by Susan Frame.

Leaves

The first strokes of the orchid are the leaves. The flowers come next, then the flower stem. The orchid leaf is painted using a pressure stroke. Sit up straight, hold your brush in an upright position and hold the paper still with your other hand to keep it from moving.

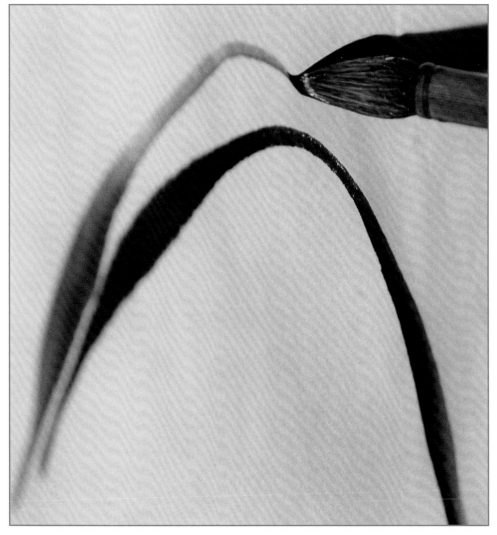

Leaf stroke.

Step 1

Beginning on the lower part of your paper, touch the tip of the brush to the paper. Exert just a little bit of pressure at the beginning of the stroke, then lift and skim the brush across the surface of the paper. While skimming, push down the tip of the brush and lift again. Keep your speed consistent and use your whole arm during this push, lift, push movement across the page. To end the leaf, gradually lift until your brush is off the paper.

Orchid leaves are pulled down by gravity and the weight of the leaves. They should curve down easily. If the leaves point upwards and appear to wiggle, they aren't orchid leaves. However, don't forget how you painted those 'non-orchid' leaves because you can use the technique for other subjects, like underwater plants.

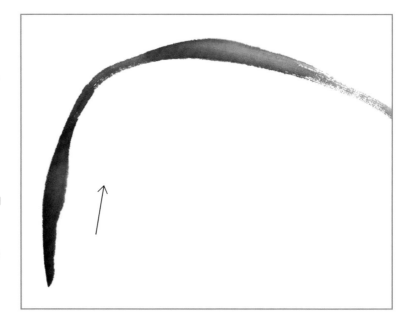

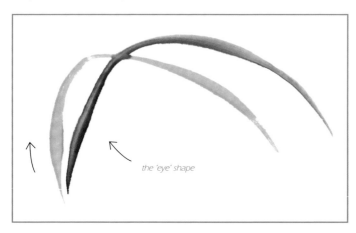

the 'eye' shape

Step 2

You may paint the orchid plant with three or more leaves. The individual leaf strokes should cross occasionally to keep the painting interesting and flowing. Traditionally, the first and second brush strokes form an 'eye' shape.

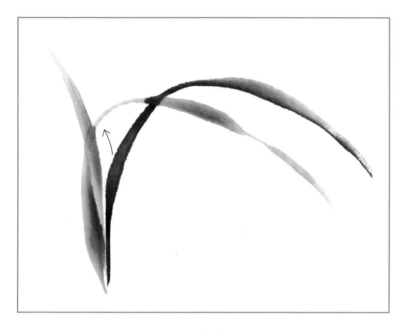

Step 3

The third brush stroke cuts through that "eye" shape in some direction. Leaf clumps are formed by creating and cutting through the "eye" shape.

Step 4-5

Clumps indicate that it is a whole plant rather than individual, grasslike leaves. The demonstration shows the graceful brush movement and the stroke order. Orchid leaves provide an opportunity to show depth by playing with dark and light in your composition. The leaves that are closer are darker, meaning that you'll load proportionately more dark ink on the brush than light ink. The leaves that are farther away are lighter and have proportionately more light ink than dark. The leaf tips, or at least most of them, should taper off to a nice smooth point. It's fine if some of the tips are a little ragged because they can be leaves with character. However, if all of your leaves are ragged, your taper-off technique is a little ragged as well.

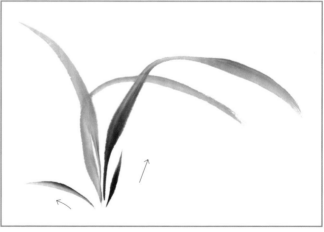

Flowers

The large brush is also used to paint the flowers. Two different kinds of wild orchid are frequently painted, the main difference being the number of flowers on the stem. The orchid in your painting may have one flower per stem or it may have many flowers per stem. Either way, each orchid has five main petals, with a central funnel-like area. The funnel of the wild orchid is very small, and in painting terms is called the "flower heart".

Wild-orchid petals are usually painted light in color, with a bit of black on the tip of the petal. That means that you load the brush with light ink, then add a little dark ink to the tip of the brush. Each petal is made with a short pressure stroke, so sit up straight and hold the brush upright while you hold the paper with your other hand.

Brush and orchid-petal stroke.

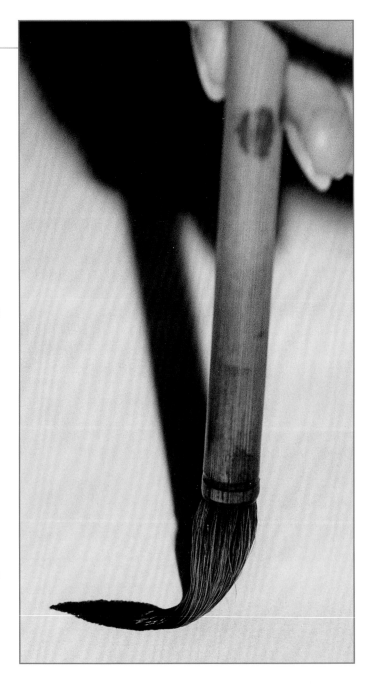

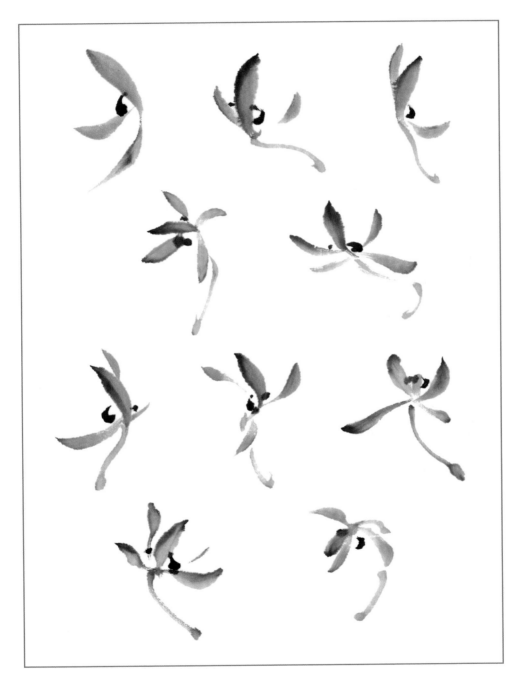

Flower views.

Now lightly touch the tip of the brush to the paper, push down a little on the tip, pull the brush a very short distance across the paper, then lift. This is basically the same stroke that you used to paint the leaves, except it's much shorter. As with the leaf, don't lift up your brush abruptly. Since it's such a small stroke, you barely push down and drag before it is time to lift the brush gradually off the paper.

Orchid petals are painted towards the center of the flower. Imagine where the center is and what each petal is doing. Begin at the outer tip of the petal and, using the pressure stroke, pull in to the center of the flower. All of the petals should point to the center, or should suggest a center, but don't intersect them at the center. You'll risk getting a blob at the intersection point or a dark center of interest where you don't want one.

Step 1

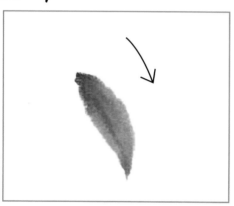

Step 2

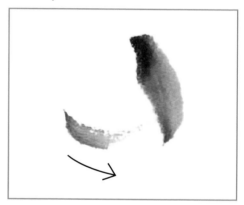

Step 3

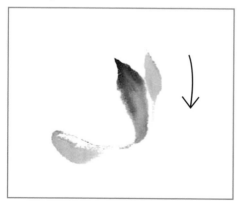

Step 4

Orchid-painting is very rhythmical, and when I paint orchids my brush dances. The stroke movement is from outside inwards, and from side to side. For example, let's say that the first petal is the central one. The stroke begins on the outside tip of that first petal and the brush pulls in and lifts.

Without interrupting the flow, it moves to the outside petal on the right side of the flower, then, without interruption, moves to the outside petal on the opposite side again and so on. My brush dances from top to bottom and from side to side.

Step 5

Step 6

Step 7

Step 8

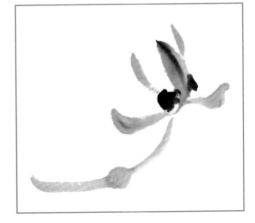

You should be able to paint the orchid from any angle, with any number of petals opened. That means that you should be able to paint buds, as well as partially opened, or fully opened, flowers. Multi-flower stems have a progression of blooming. The flowers lower down on the stem bloom first, so the buds are nearer the tip of the stem. If you're painting more than one flower on a stem, you'll also need to pay attention to the placement of the flowers. Start by imagining the stem and where it is in relation to the leaves. Then imagine where the flowers are on the stem. Leave the stem until last.

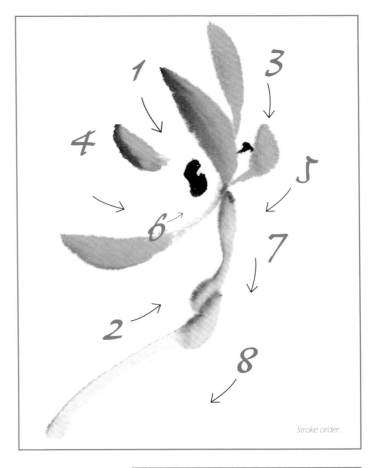

Stroke order.

When you've finished the flower petals, it's time to paint the flower hearts. To the uninitiated, these strokes may look like haphazard dots, but they are placed with great care and with an emphasis on calligraphic technique. To paint the flower hearts, use a small brush with dark ink. Using a quick, but gentle, movement, push down, then lift up. Usually the flower has two or three "dots", but if it's partially opened you may only see one. These hearts represent the funnel area of the orchid.

Key Points

1. Load brush with water, light ink and dark ink.
2. Using pressure strokes, paint long, graceful leaves with tonal variation.
3. With short pressure strokes, paint the flower petals. They should be tipped with black ink.
4. Paint the flower stem and attach the flowers to it.

Stem

Now your painting has leaves and floating flowers that need a stem. Before you began your painting, you imagined where your stem and flowers would be. The chances are that your hand and brush have not responded exactly as planned. Don't worry if the flowers aren't exactly in the right spot. You'll just need to change your idea a little.

Just as the leaves and flowers flow gracefully, so the stem should have movement. Straight stems look awkward, so try for a little curve in your stroke. The stem is a pulling stroke without pressure. Load the brush with mostly light ink and a just little dark ink. Blot off the excess. This is a

relatively small stroke, so if there's too much liquid on the brush it will really show. Now simply set the brush tip on the paper and pull from the outside-stem end towards the clump of leaves. When you reach the clump, lift the brush.

At this point your flowers are floating and need stem attachments. Load the brush with light and dark ink, blotting it carefully. Using just the tip of the brush, begin the stroke at the flower and pull it to the stem. Stop at the stem, using just a little pressure so that the stroke looks like it's attached to the main stem. Do this for each flower.

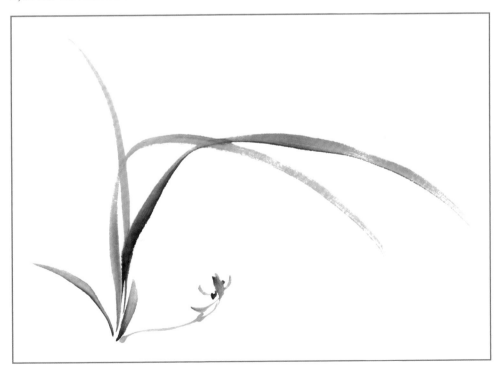

Simple composition.

Painting the
Bamboo

Bamboo,
by Susan Christie.

Bamboo stands for summer and symbolizes strength and flexibility. Bamboo is so strong and flexible that it can blow over in the wind and spring back up when the storm has passed. It is important to paint it using strong strokes, without hesitation. To begin, tear your paper to size and mix dark and light ink. The order of painting will be the stalk first, then the leaves and finally the branches.

Stalk

Begin the stalk by loading a large brush with clear water, then light ink and finally dark ink on the tip. You don't want to run out of ink while painting the stalk, so be sure to have enough ink on the brush. It will be difficult to re-load your brush in the exact same proportions and the continuity and strength of the stroke will be broken if you have to stop. Think about where you'll place the brush and the direction of the stalk before you begin, then stop thinking while you do the stroke. If you don't stop thinking, your stroke will show hesitation. Because this is an energetic stroke, be sure to hold the paper with your other hand to prevent it from moving around.

The bamboo stalk is divided into sections. Each section begins with a little extra brush pressure and ends with a little pressure. You will lift the brush completely off the paper between sections. Begin at the bottom of your page on the bottom section. Hold your brush at an angle, with the tip pointing to the side of the paper. Lay it down and exert a little pressure. Moving your whole arm, quickly drag the brush up the paper for a few inches, stop, exert a little pressure and lift it completely off the paper (1).

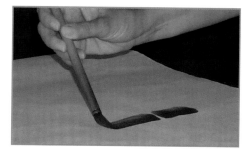

Hand and brush position: bamboo-stalk side stroke.

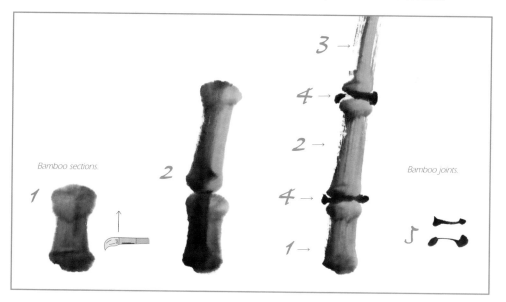

Bamboo sections.

1

2

3 →

4 →

2 →

4 →

1 →

Bamboo joints.

This is the first bamboo section. Without re-loading the brush, repeat the process to paint the second section (2). Repeat it again for the third section(3). Each section is longer and narrower than the previous one as you move from bottom to top. If your brush runs out of ink before you finish the stalk, you'll know that your brush was too dry or that you moved the brush too slowly and the paper absorbed the water.

If you look at various bamboo paintings, you'll notice that stalk strokes are not solid and frequently have white, empty spaces. This is called the "flying-brush" technique and is caused by your brush moving quickly across the paper. It shows energy in your brush stroke.

Next, paint the dark joint strokes that separate the sections. These are pulling strokes, with pressure on each end of the stroke (4). The stroke curves slightly to show the roundness of the stalk. Using dark ink, hold the brush straight upward. Push down with the tip of the brush, then lift and pull the brush between the stalk sections. Push down again on the other side of the stalk and then lift the brush off the paper. Paint the joint while the stalk sections are still damp to allow the strokes to bleed together a bit (5).

Leaves

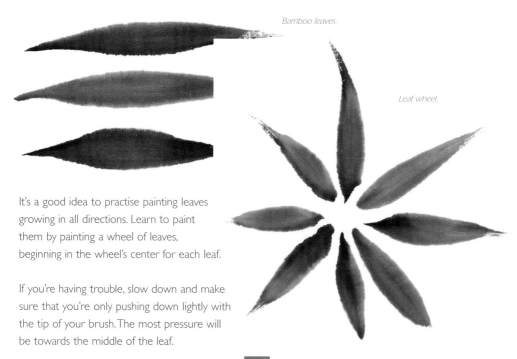

Bamboo leaves.

Leaf wheel.

It's a good idea to practise painting leaves growing in all directions. Learn to paint them by painting a wheel of leaves, beginning in the wheel's center for each leaf.

If you're having trouble, slow down and make sure that you're only pushing down lightly with the tip of your brush. The most pressure will be towards the middle of the leaf.

Leaves are painted after the bamboo stalk. Leaves are made with pressure strokes. They're shorter than orchid leaves, but longer than orchid petals. To paint a leaf, load both light and dark ink on a large, brown-haired brush. Hold it straight upward, perpendicular to the paper. Begin your stroke with a light touch, pull the tip and exert more pressure at the same time, then slowly lift. Continue the lifting and moving until you're off the paper. This is mostly an arm movement, so don't let your wrist or fingers take over.

If your leaf looks like a tadpole, with a thick body and an abrupt, skinny tail or no tail at all, you had too much wrist movement or lifted the brush too suddenly. Try it with a smooth, gradual movement. Press down a tiny bit when you begin the stroke so that the stem end of the leaf will be a little heavier than the tip. Paint the leaves in the direction that they grow, from stem end to leaf tip.

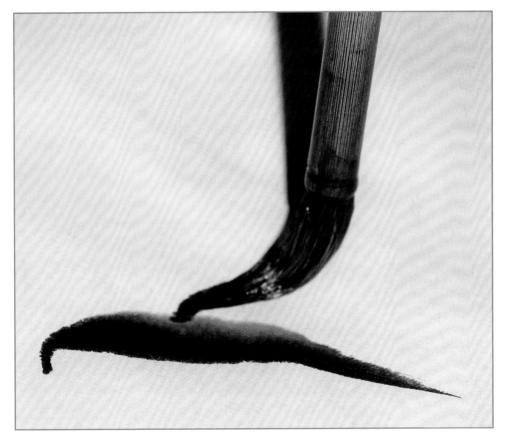

Brush and leaf stroke.

Leaves are usually painted in groups, with one to five leaves in a group. Darker leaves represent nearer leaves, lighter ones are farther back. Use more dark ink on your brush to paint darker leaves and less dark ink to paint lighter leaves. When painting bamboo leaves, it's acceptable to run one stroke right over the other stroke. However, be careful that your brush isn't too wet or you'll have big, wet blobs.

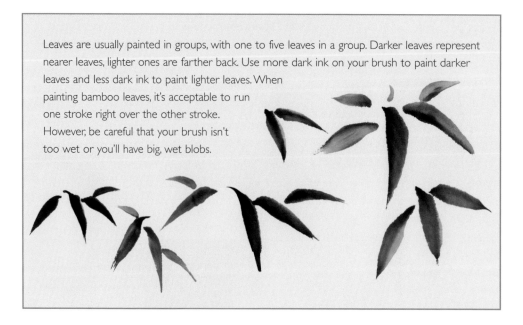

Now you have a stalk and some leaves that need branches. Branches are made with minipulling strokes that grow out of the bamboo joints. Paint the branch sections with the tip of the brush. Remember, dry doesn't mean that you've taken all of the ink off. Dry means that you've blotted your brush a lot after rinsing and after loading light ink. You'll also still need a bit of dark ink on the tip of the brush.

Branches.

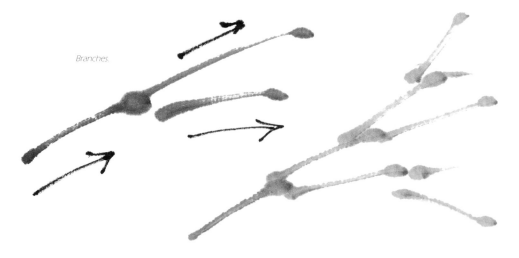

Hold your brush upright and pull it, lightly touching the paper. Stop at the end of the section, push down a little bit and lift. The branches form the shape of a "Y". Using the "Y" formation at the end of branch sections allows you to go wherever you want with that branch. As with the stalk, branch sections become narrow and longer as they grow.

Simple composition.

Key Points

1. Load your brush with water, light ink and dark ink.
2. Using a side stroke, paint the stalk in sections, with pressure
at each end of the section. Lift the brush between sections.
3. Paint leaves using a pressure stroke.
4. Paint "Y" branches with a pulling stroke.

Painting the
Plum Blossom

The plum blossom symbolizes winter because in Asia it often blooms in February, before spring arrives. In colder climates, it's not unusual to receive a last snowfall while the plum blossoms are in full bloom. Plum blossom personifies austerity. A plum-blossom painting usually includes a main branch and a secondary branch, flowers and small branches. You'll use the side stroke, the pulling stroke and the smooshing stroke.

Paint the main branches first, then the flowers, then the smaller branches and the stems connecting the flowers to the branches.

Preparation

1. Load your brush with water, light ink and dark ink.
2. Using side strokes, paint branches with a rough texture.
3. With smooshing strokes, paint the flower petals. They should have tonal variation.
4. Paint small branches using pulling strokes. Create depth with light and dark strokes.
5. Attach the flowers to the small branches.
6. Use a very small brush and dark ink to paint the flower centers.

Spring Bursting Forth, by Susan Frame.

Branches

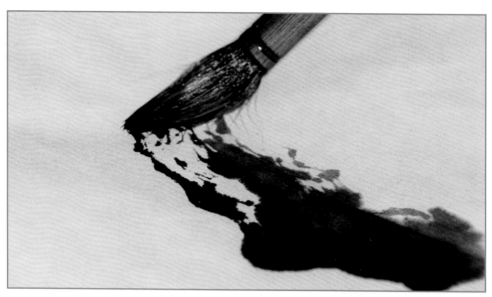

First use a side stroke . . .

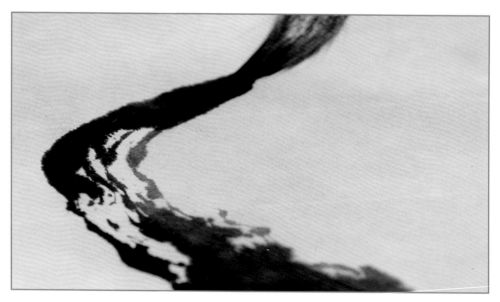

. . . then turn and pull the brush.

Step 1

Begin by tearing the paper, preparing dark and light ink and composing yourself. Use a large brush for the branch. First, rinse your brush and blot off the excess water. Then load the brush with light ink three-quarters full and tip with dark ink. The first branch will be the darkest, so put an extra amount of black ink on the tip. Holding your brush at an angle in the side-stroke position, move the side of the brush across the page in a somewhat jerky movement similar to a zigzag. As you near the end of the branch, turn your brush and pull it to make the branch thinner.

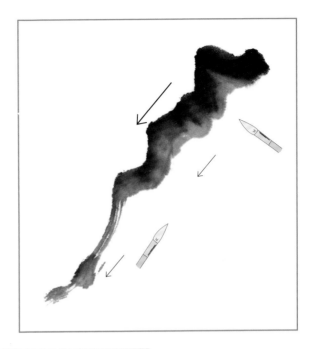

Step 2

Now rinse your brush and re-load it with tones of ink. This time, use less black ink on the tip so that your second branch will be lighter in color. Paint the second branch in the same way that you did the first, by holding your brush at an angle and pulling the side of the brush across the paper. As it moves, turn it and pull it. When pulling, your hand leads the way in the direction of the stroke and the brush hairs follow.

Step 3

Look at the two branches that you have just painted. Are they gnarled and rough? To add more texture and contrast, paint some dark, pointed brush strokes on areas that you'd like to accent. The plum branch is often called the "dragon's back" because of this rough shape. If some white, "flying-brush" areas appear, that's fine.

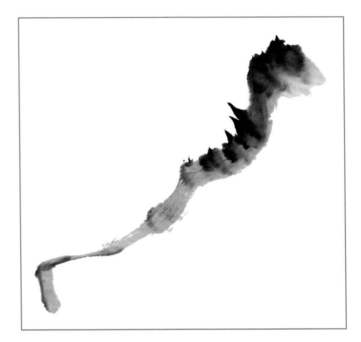

Flowers

A plum-blossom painting may have few, or a profusion of, flowers. It's your choice. Like the wild orchid, the flowers bloom in a certain order on the branch. In fact, this is true of all flowers. The buds are on the tips and new growth is at the end of the stem. The flowers become progressively more open as they move inward on the branch.

To paint the flowers, use a large brush and smooshing strokes. If you plan to paint small flowers, you could use a smaller brush. Rinse your brush, blot off the excess water, load it with light ink and blot, then load the tip with dark ink. The brush should be fairly dry for this stroke to prevent excessive bleeding

into the paper. You'll know when you begin if the brush is too wet or too dry.

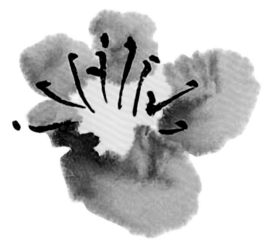

Step 1

Start with flowers that are fully open. A fully open plum blossom has five petals. Holding your brush in a straight, upright position, touch the tip of the brush to the paper and push down a bit. Smoosh the heel of the brush to the side while the tip points towards an imaginary center of the flower, then lift the brush off the paper. The stroke should look like an imperfect circle, with the darker tone at the tip.

Flower petals: brush-tip smooshing.

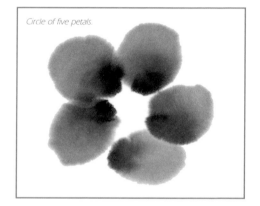

Circle of five petals.

Step 2

Continue around the imaginary center of the flower, painting four more petals using this smooshing technique. Manipulate the brush with your arm, wrist and fingers rather than moving your paper to a new position.

Step 3

For larger flowers, push down and smoosh with a fair amount of pressure. For smaller flowers, barely push and let the ink spread of its own accord to form the shape of the petal. To maintain beautiful ink tones, you may have to stop and reload your brush. If you do, remember to match the tone of the last petal when you reload for the next one. All of the petals of one flower should be of the same intensity.

When you've painted all of the petals of one fully open flower, create some depth by painting partial blossoms next to the fully open one. The partial blossoms will appear to be behind the open one. To paint a partial blossom, paint fewer petals, as though some were hiding.

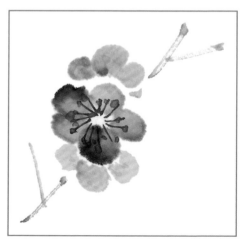

Petals

Other flower views are also painted using the smooshing stroke. The difference is that some of the petals are larger or smaller, wider or thinner, depending on the view. The two main things to remember are: beautiful shading in each petal and continuity of color within one flower.

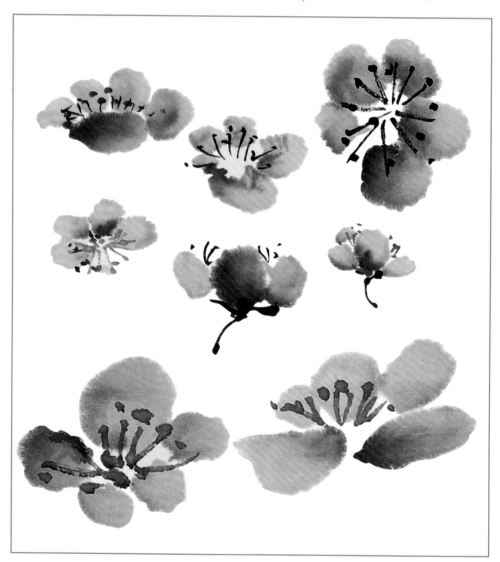

Step 4

Using the smooshing stroke, paint a few more flowers and a bud. As you're painting them, imagine that they're all on one small branch. This way you'll paint them grouped together and they'll easily grow on one branch.

When the flowers are nearly dry, paint the centers. Traditionally, only seven stamens are painted, but I always paint more than that because I like the look of a more crowded flower center.

Each line representing a stamen also has a dot near the end. Paint these centers in dark ink so that they attract your eye as you look at the painting.

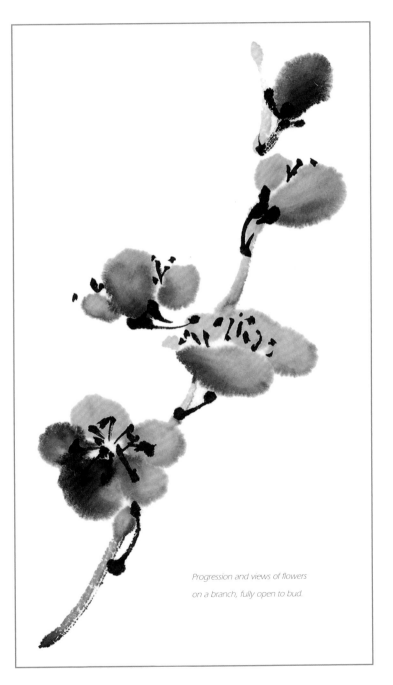

Progression and views of flowers on a branch, fully open to bud.

Composition and Development

Step 1

Paint the main branches, then add flowers.

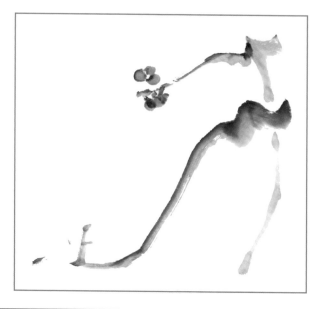

Step 2

Paint the flowers, including partial blossoms behind blossoms.

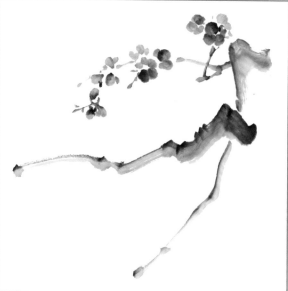

Step 3

To finish the painting, add small branches and stamens.

Paint the small branches using an upright brush and a pulling stroke. Learn to paint them with a large brush, and you'll develop good brush control. To create interest and depth, some branches should be darker and some lighter. If you're painting a lot of flowers, place some in front of the branches and some behind the branches. You can go back and forth between painting the flowers and painting the branches to develop depth.

Finally, your flowers should connect to the branch. Front-view flowers just need a small pulling stroke to paint the connection. Back-view flowers will also need a calyx to cup the flower.

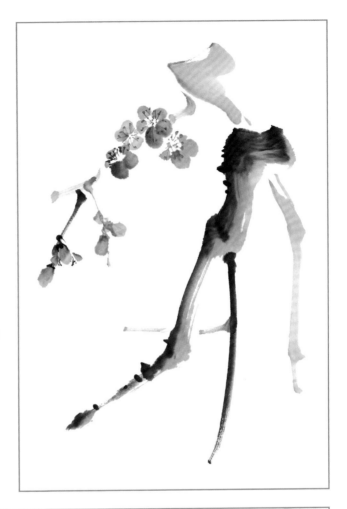

Key Points
1. Load the brush with water, light ink and dark ink.
2. Using side strokes, paint branches with a rough texture.
3. With smooshing strokes, paint the flower petals. They should have tonal variation.
4. Paint small branches using a pulling stroke. Create depth with light and dark strokes.
5. Attach the flowers to the small branches.
6. Use a very small brush and dark ink to paint the flower centers.

Painting the
Chrysanthemum

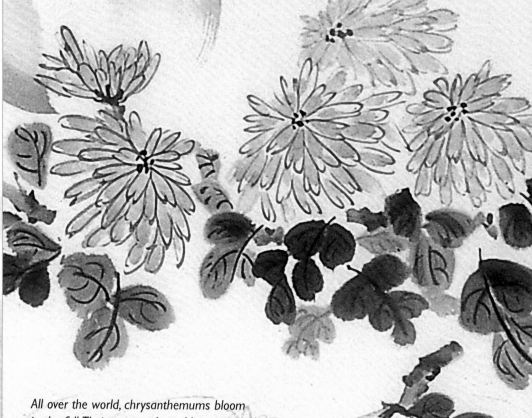

All over the world, chrysanthemums bloom in the fall. Their spectacular gold, orange and maroon colors defy the frost and the colder weather still to come. Because of this, chrysanthemums symbolize righteousness.

Mum at Autumn Moon,
by Susan Christie.

Preparation

You'll use your large brush for both the flowers and the leaves. Use pressure strokes and smooshing strokes, beginning with the flowers, then the leaves and the stems.

Flower

We'll paint a spider mum, so begin by imagining the beautiful flower while you tear the paper and mix shades of ink. Now rinse your brush and load it with light ink and dark ink. Use a little extra dark ink for the darker flowers. Envision the center of the flower because each petal will point towards it. Begin painting the inside petals and work outwards. Sit up straight and hold your brush upright. Push down on the tip of the brush and then lift and pull the stroke to the center of the flower. Lift up as you near the center so that your stroke becomes less heavy. The central petals are often a rounded clump because they're not yet open. Moving from one side to the other of the rounded clump, paint some petals, all pointing inwards, towards the center. Vary the length and angle of each petal so that your painting is interesting.

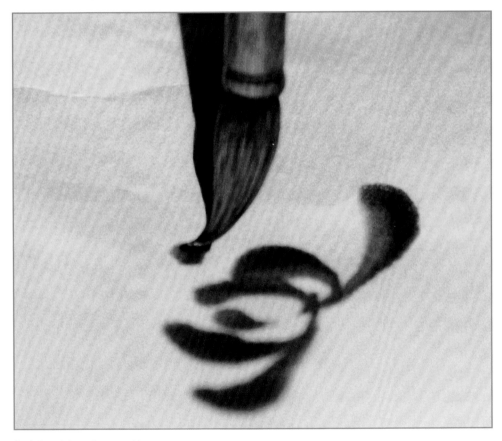

Brush tip and chrysanthemum petal.

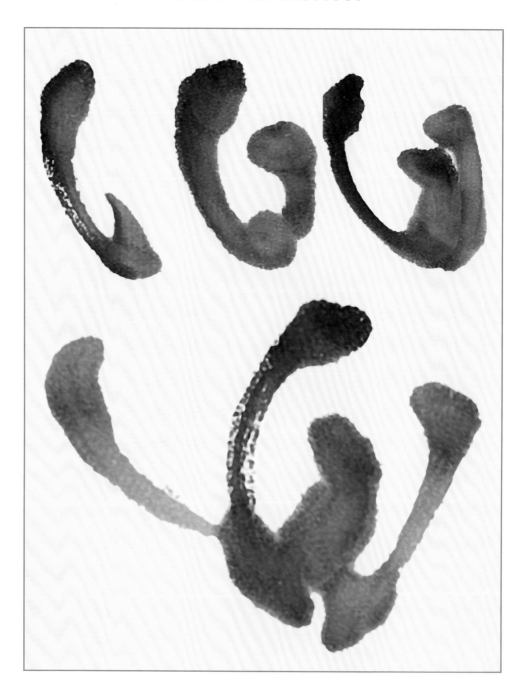

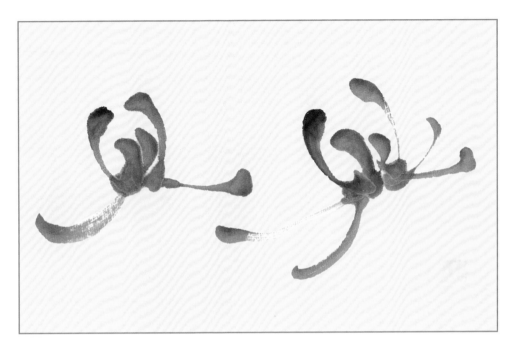

As you move away from the flower center, the colour of the petals should become a little lighter. For lighter petals, use less black ink on the tip of your brush. These petals should be filled with movement. To help you to capture the movement, think of them as dancing and paint one doing this and one doing that. You may cross one petal stroke right over another petal stroke as they dance on your paper.

Stem

When you look at a chrysanthemum in a pot, the stems often look very straight because they've been pruned. Mums that haven't been pruned have interesting curves. If they're allowed to grow naturally, they may become vinelike, twisting all over the ground and around any nearby rocks.

To paint the stem, rinse the brush and load it with light and dark ink. Hold it upright and pull it from the flower toward the ground, exerting just a little pressure. The stroke shouldn't be fat, but it also shouldn't be too thin to support the flower. Put a little curve into the stroke to keep it looking interesting.

Leaves

Chrysanthemum leaves need calligraphic strokes. The strokes are energetic and require pulling, pressure, and smooshing in one continual movement. Each leaf is composed of a number of lobes, or elongated, roundish sections. Usually three or five lobes are painted, depending on how much of the leaf is showing.

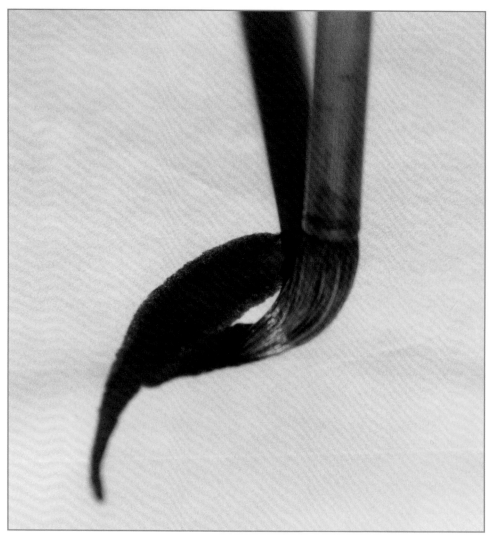

Painting a leaf.

Begin by loading both light and dark ink onto your brush. Create the first lobe at the end of the leaf by pushing down on the tip and on the heel of the brush to paint an elongated circle. Then, in one movement, release the pressure and drag the tip to the second lobe position. Push down on the heel of the brush, then lift and drag to the third lobe position. Lift the brush and position it near the end lobe.

Paint the two lobes on the other side of the leaf stem. A couple more leaves will make your painting more interesting, so add some, using the same technique. Try to keep your brush movement smooth and fluid. When the leaves are damp, but not dry, add the leaf stem and veins using a small, dry brush.

Step 1

Step 2

Step 3

Step 4

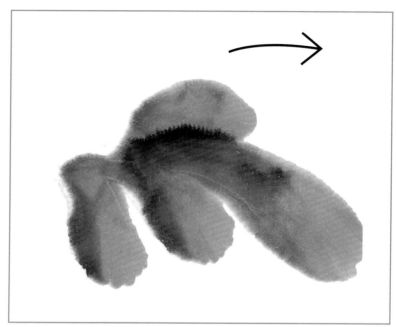

Step 5

Step 6

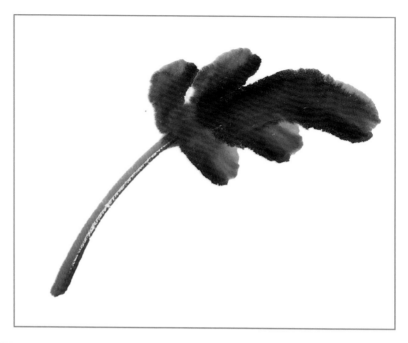

Step 7

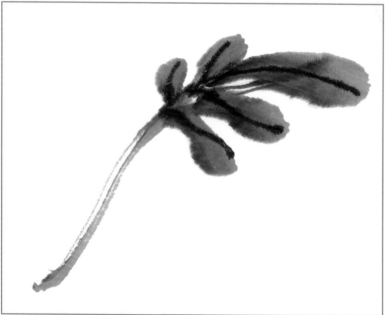

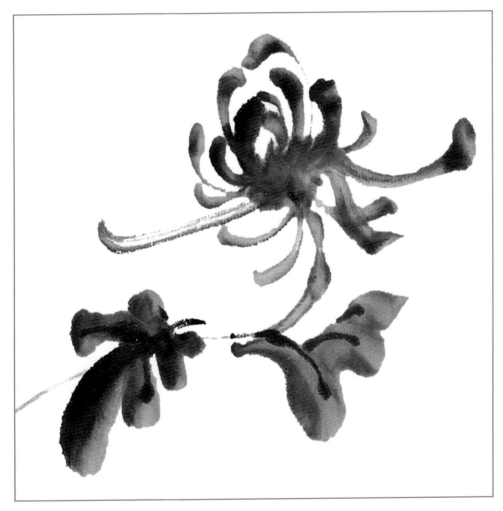

Simple composition.

Key Points

1. Load the brush with water, light ink, and dark ink.
2. Using a pressure stroke, paint the petals with tonal variation and movement.
3. Paint the stem with a pulling stroke.
4. Paint calligraphic leaves with a continuous pulling/pushing movement.

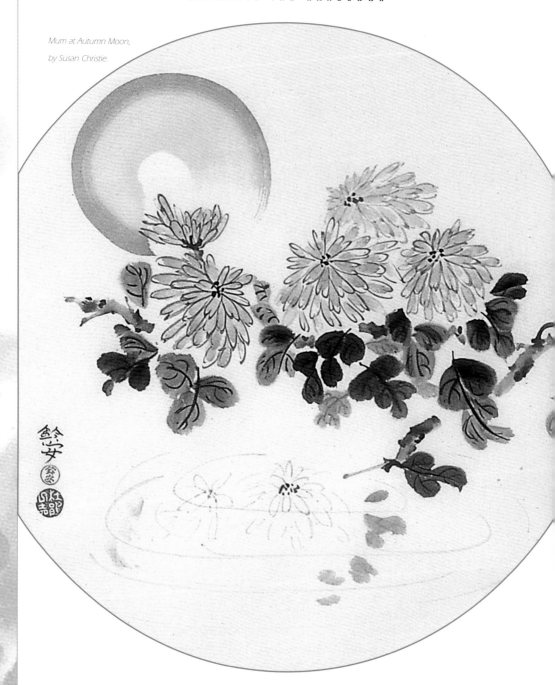

Mum at Autumn Moon,
by Susan Christie.

Easy
Japanese Ink Painting

In my
demonstrations,
I use tubes of
watercolor
because they
are readily
available.
You may use
Chinese or
Japanese colors
if you prefer.
When using color,
you need three
brush-rinsing containers
or one container
with three
sections.

Rinse
black,
green and
blue in one,
red, orange and
yellow in
another, and
save the last for
white and very
light colors.

Preparation

Black ink is used in all Sumi-e, even those
with color. It adds excitement to the
painting and is used to tone down overly
exuberant colors. Remember that the
definition of Sumi-e is "ink picture".
Without ink, your work is not Sumi-e.

Brush Loading Techniques

Intense (left) and light (right) red.

Brush-loading techniques are just as important when using color as when using black ink. The same theory applies: you need more than one tone of color, or more than one color, on your brush to produce a variety of tones or colors in the actual brush stroke on the paper. Let's try a couple different ways to accomplish this.

First, squeeze some alizarin crimson (red) out of the tube on to a small plate. Add a little bit of water to it and mix with a small brush. The aim is to dilute the color slightly with water so that it will load easily on to your brush. The more water you add, the lighter the color will be. This first plate of red should be very intense and saturated, so don't add much water. It should be the consistency of cream. You'll know it's too thick if the color has texture on your brush or paper. We'll call this intense red.

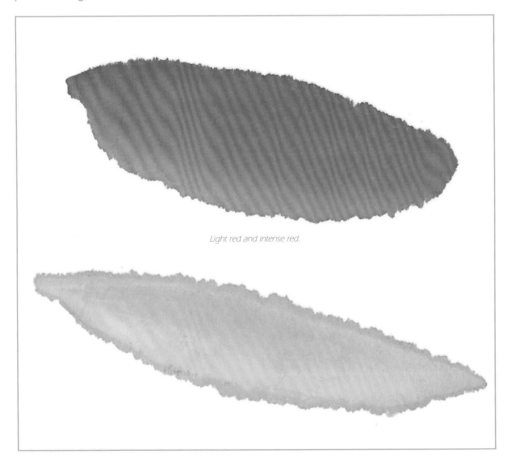

Light red and intense red.

Make a second plate of red, but this time use more water. The color should be quite diluted and light. We'll call this light red. Using the light and intense red, load the brush the same way you did for light and dark ink. First load clear water, then blot the excess liquid off, then load light red and blot and, finally, add the intense red to the tip of the brush. As you pull the brush across the page, you'll see the various tones of alizarin crimson, from very light to brilliant.

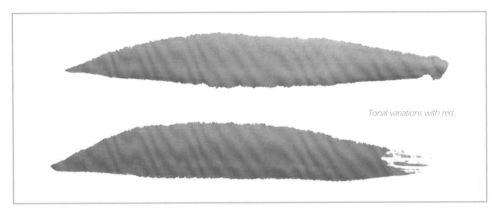

Tonal variations with red.

Brush-loading is also done with two separate colors instead of various tones of one color. First, mix the intense red as you did earlier. Now mix a second color by squeezing dabs of alizarin crimson and gamboge yellow on to a plate. Add just enough water to mix. Use your small brush to mix it thoroughly. Depending on your proportions, you'll have a shade of orange. After rinsing and blotting the brush, fill it about three-quarters full with orange, blot a little and add some intense red to the tip. Now you're ready to paint in brilliant color.

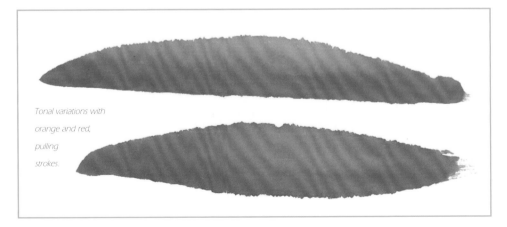

Tonal variations with orange and red, pulling strokes.

109

Try a side stroke with orange and red to see the full effects. Take a close look at the side stroke that you have just painted. Does it have stripes because the colors don't blend together? You don't usually want this "candy" stripe effect. If you've got it, you'll need to do some brush-blending (after you load the colors, but before you paint the stroke). So rinse your brush and start again. Load the clear water, blot, add orange, blot, and add intense red. Now drag the brush across the surface of a clean plate, as if you were painting, and gently force the colors on the brush to move together. If you blend too much, you'll have a solid color. Try the side stroke again. Are the stripes softer, do they blend together more, are they less delineated? If so, you've blended successfully.

Stripe effect.

Blended effect.

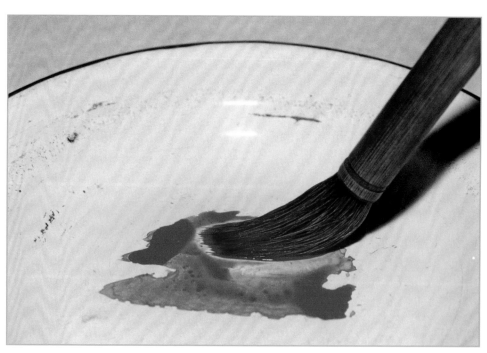

Moving brush on plate.

Experiment

As a third experiment, try loading three colors instead of two. This time you will need a plate of intense red, a plate of light red, and a plate of orange. Start with clear water on your brush, blot, add ¾ full of light red, blot, add orange, blot, add intense red. Blend a little bit on your extra plate. Paint a side stroke down the center of your page and you'll see a beautiful example of brush-loading.

This is the basic color-loading technique for all colors. To become familiar with color-loading, experiment with the color-loading order. Try changing it around and add the intense red before the orange. Experiment with the wetness and dryness of your brush, too. Also experiment with the effect of color on pulling strokes, side strokes, and smooshing strokes.

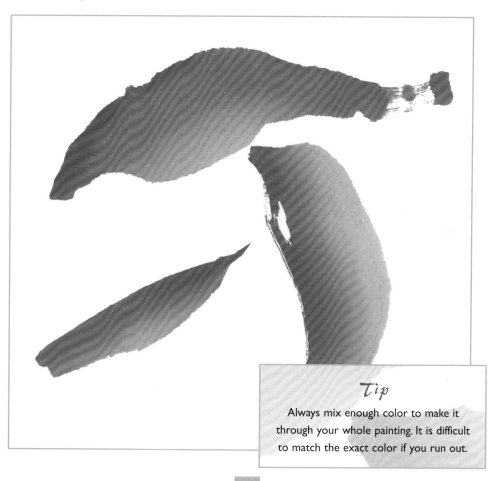

Tip

Always mix enough color to make it through your whole painting. It is difficult to match the exact color if you run out.

How to Paint
Cattails

Cattails make a good subject because most people are familiar with them. The sun adds drama to the painting.

You'll be using pulling strokes, side strokes and smooshing strokes.

To begin

Mix light and dark shades of ink. Next, prepare brown by mixing burnt sienna with water. The consistency should be similar to that of your dark ink. Also mix the color orange by combining yellow and red. Finally, mix some intense red.

Leaves

Rinse a large brush, blot it and load it with brown. Blot it and add some light ink to the brush. Blot it and add black ink to the tip of the brush, enough to make your brush stroke dark. Holding your brush upright, use a pressure stroke to paint the first leaf. Lift the brush as you near the point where the leaf folds over. Push down on the brush as you change direction to show the folding or broken leaf. Taper off at the end of the stroke by lifting the brush gradually. This first stroke is dark because it is the focal-point leaf. Paint additional leaves in lighter shades to create depth perspective.

Finish the plant by adding more leaves. Some of the leaves should stand pointing straight upward, while others fold over or break. Don't worry if some of the points are split. By the time cattails have grown to this stage, they are probably a little bedraggled.

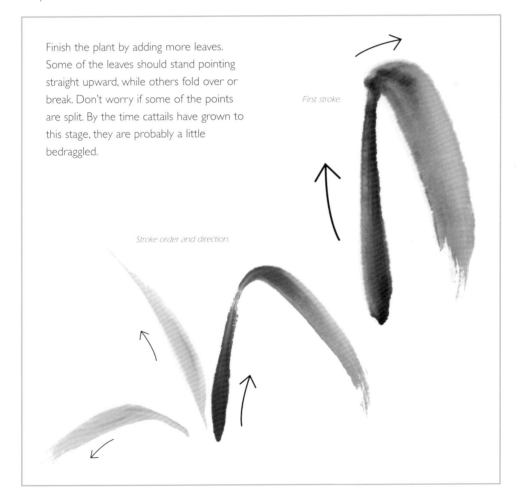

First stroke.

Stroke order and direction.

For the cattails, rinse and load your brush with brown color, then light ink, then dark ink. Use more dark ink for the darker one and less for the lighter ones. This side stroke is very similar to the bamboo-stalk stroke, but because there are no joints, you don't need the extra pressure at the beginning and end of the stroke. Use the same large brush and a pulling stroke for the stem. Pull from the cattail down to the base of the plant. The stem also extends above the top of the cattail, so don't forget to paint it with the same color tones as the rest of the stem.

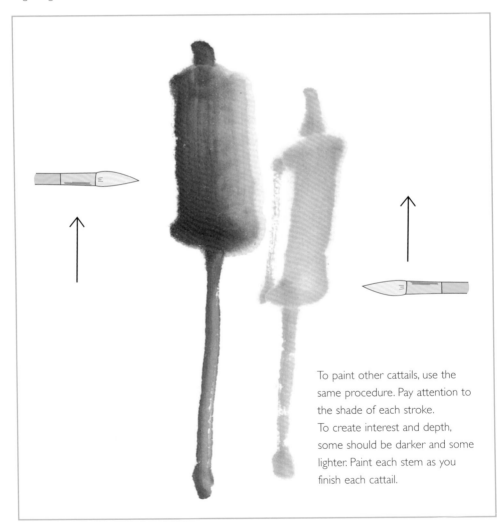

To paint other cattails, use the same procedure. Pay attention to the shade of each stroke. To create interest and depth, some should be darker and some lighter. Paint each stem as you finish each cattail.

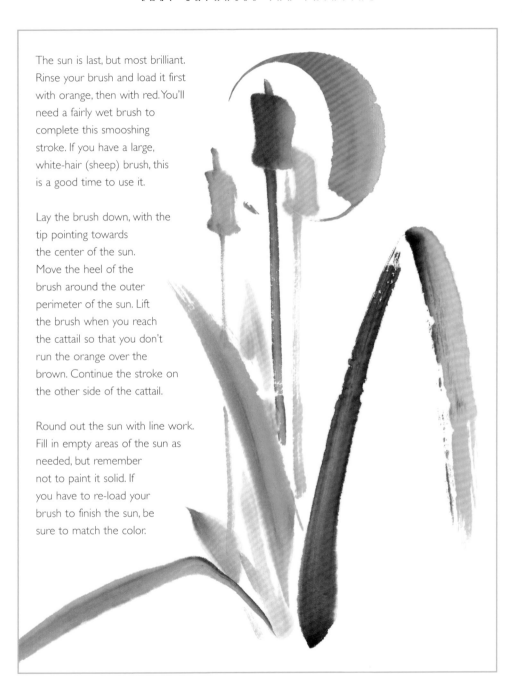

The sun is last, but most brilliant. Rinse your brush and load it first with orange, then with red. You'll need a fairly wet brush to complete this smooshing stroke. If you have a large, white-hair (sheep) brush, this is a good time to use it.

Lay the brush down, with the tip pointing towards the center of the sun. Move the heel of the brush around the outer perimeter of the sun. Lift the brush when you reach the cattail so that you don't run the orange over the brown. Continue the stroke on the other side of the cattail.

Round out the sun with line work. Fill in empty areas of the sun as needed, but remember not to paint it solid. If you have to re-load your brush to finish the sun, be sure to match the color.

How to Paint
a Pine Branch

The pine is very strong and represents longevity. It can grow out of rocks in the side of a cliff for hundreds of years. I think of the pine as old and wise.

Unless it is part of a landscape painting, usually only a few branches of the pine tree are painted.

The trunk and main-branch techniques give you a chance to practice your dry-brush side stroke, while the needles introduce a fine, thin stroke requiring good brush control.

Preparation

Prepare your colors by mixing light and dark ink, as well as some light yellow-green (indigo and yellow, use more yellow) and light blue-green (indigo and yellow, use more blue). You'll also want a little bit of magic green.

Pine trees have rough, textured bark, and the branches can be quite angular.

Try to capture these characteristics by using quick strokes and a dry brush. For the main branch, load both light and dark ink on a large brush. Using a side stroke, pull the brush from the trunk side of the branch to the tip. Turn the brush and pull it for a thinner section of the branch. Lift the brush off the paper to leave white areas for pine needles in front of the branch.

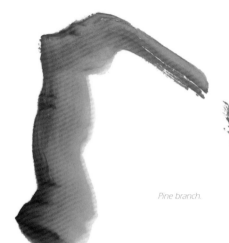

Pine branch.

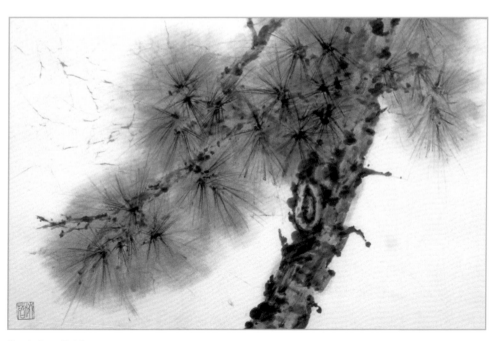

Pine, by Susan Christie.

If you are able to control the liquid on your brush fairly well, you can also use your large brush for the pine needles. If many of your strokes in these exercises have been too wet, use your small detail brush. Make sure that your brush is very dry after you load the light and dark ink. Be sure to blot excess water out of the heel, as well as the tip. Hold the brush straight up and keep your arm off the table. Use a whole arm movement.

Paint the needles in the white space that you left in the main branch. Use a very light touch to paint them and have both light and dark ink on your brush. Paint them in clumps, radiating from a central point of each cluster, and try to have tonal variation in each stroke. Some of the needles should cross over others and the space between the strokes should vary. To make things even more interesting, paint some of the needles a little darker and some a little lighter.

Paint secondary branches using the same technique, but a little lighter in color and a little smaller and less heavy. The smallest branches are done with a pulling stroke. I usually paint small branches and then add pine needles, but it really doesn't matter which is done first. Make sure that the needle clusters are connected to branches. If they aren't, add a pulling stroke to make the connection needed.

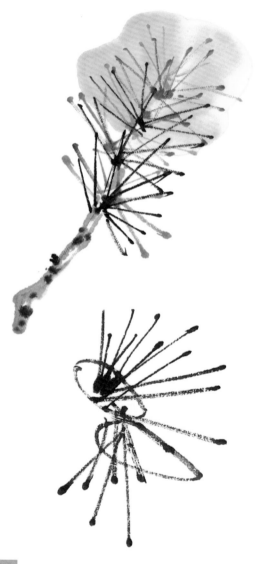

The addition of a color wash to the pine-needle clumps will soften the image. Add the wash after the needles have completely dried so that they don't run when you paint on top of them. Load a large brush with water and light yellow-green. Tip it with blue-green. Test the color on a scrap of paper to make sure that it's very light because the color wash should complement, but not become, the center of interest. Using slow side strokes, apply the color in the same direction as the needles. Paint slowly so that the paint and water bleed into the paper. Vary the colors for other needle clumps. Try loading with water, then light blue-green tipped with yellow-green. The colors should be soft and fluid, in contrast to the rough texture of the branches and the fine detail of the needles. They should add to the painting without distracting from the brushwork.

Now analyse your painting by looking for the focal point or main points of interest. Add magic green and black dots with the tip of your brush to draw your eye to specific areas of the painting.

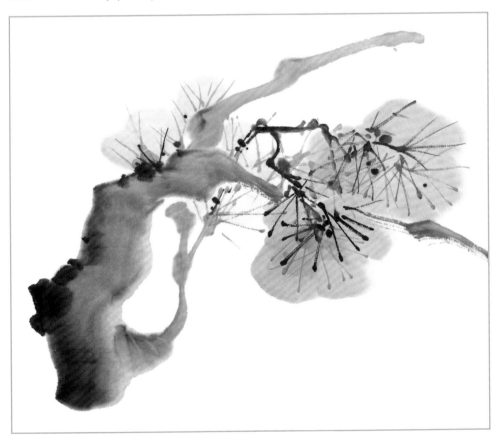

How to Paint
Irises

The iris is a favorite flower around the world. The blue and yellow flags grow wild near lakes and swamps, while the elegant Japanese and huge bearded varieties are cultivated in the garden.

*Nancy's Arrangement,
by Susan Frame.*

Preparation

To paint irises, mix light and dark inks, white gouache, purple (red and blue), intense yellow and green. Load a large brush with white and purple, then blend the colors on a plate to prevent a stripe effect. Now load intense purple on the tip.

Step 1

The stroke begins as a pulling stroke from the top of the petal. Pull towards the bottom while exerting pressure on the heel of the brush. Keep the brush moving and make a curve by dragging it sideways, then turn and pull up the page. This one movement creates a "U" shape for the first petal. If the "U" needs a little more completion, extend it by adding a pulling stroke.

Step 2

Replenish your brush for the second petal, using the same color combination. Repeat the same technique, this time pulling out towards the side of your paper, then dragging down at the curve.

Step 3

Do the same for the third petal.

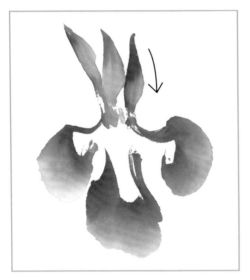

Steps 4-5-6

The fourth, fifth and sixth petals are painted with an upright brush and pressure strokes that begin thinly, become thicker and then thinner again. Be sure that you have beautiful tonal variation for these strokes.

Step 7

Each of the three bottom petals has a yellow, fuzzy area at the top where the petals join together. Because the two side petals aren't full-face views, it is not necessary to paint this fuzz on them. Paint it on the front petal, using white gouache with intense yellow.

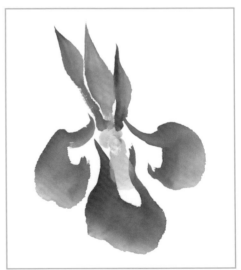

Fuzzy yellow top.

Iris Leaves

Iris leaves are usually quite stiff. Some of them are often bent or broken. To paint leaves, load green, light ink and dark ink on a large brush. The ink will tone down the green so that it is not so vivid. Begin at the base of the plant and pull out, tapering off at the tip. If your color and ink tones are beautiful, you don't need a central vein, but if your painting needs a little structure, add a vein while the leaf is still damp. Paint the stem with a pulling stroke from the flower to the base of the plant.

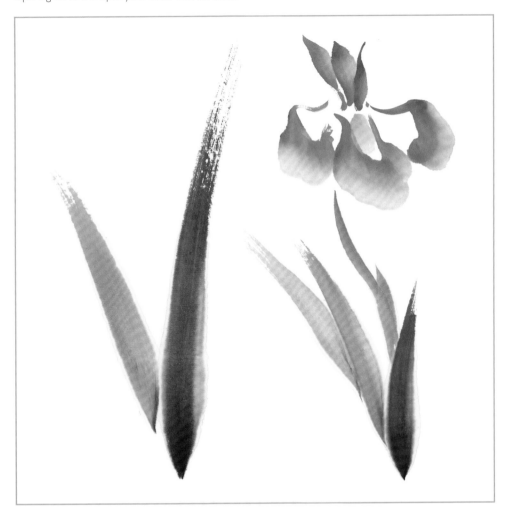

How to Paint
Tiger Lilies

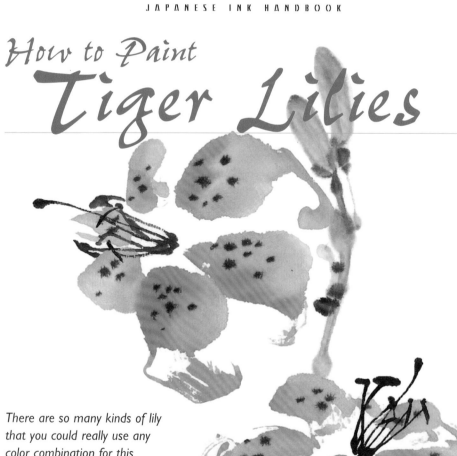

There are so many kinds of lily that you could really use any color combination for this painting. Some lilies have more of a trumpet than tiger lilies do, so you may have to modify the shape a bit, but the basic technique is the same for all lilies.

Tiger lilies are a favorite of mine because they are found in so many gardens. The contrast between the bright-orange petals and the deep black dots is spectacular.

Tiger Lily, by Susan Frame.

Preparation

To begin, mix light and dark shades of ink. Make light orange, intense orange and intense green.

Steps 1-6

Fill a large brush with light orange and intense orange on the tip. The amount of intense orange you add will vary, depending on how deep you want the petal to be. Imagine the center of the flower and, holding your brush at an angle, use a side stroke for the widest part of the petal.
As the petal twists, lift the brush to an upright position and pull the tip to finish the stroke. This technique is used for all six of the petals. Depending on the angle of the flower, you may not see the twist of the petal, in which case paint the side stroke with no brush pull. Leave a white space in the center of the flower.

Step 1

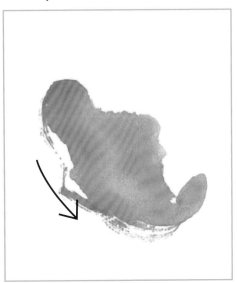

Step 2

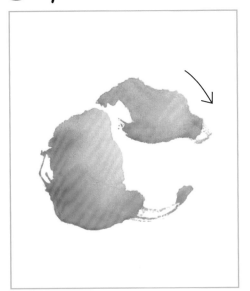

Step 3

Step 4

Step 5

Step 6

While the petals are damp, but not totally wet, paint the dots using black ink. The ink dot should bleed a little into the petal, but should not be extremely diffused.

Step 7

Wait until the flower is dry before adding the stamens and pistil. Lilies have six stamens and one pistil. Use dark ink and a small detail brush. Begin at the center of the flower and, using a dry brush, pull the tip across the paper. Each stamen has a little pollen cap (anther) on the end. The anther is painted with a little bit of pressure and can be angled or straight.

Step 8

Take a look at the spaces between each stamen and the angle of each anther. These stamens form a mini-composition and should have a variety of spaces.

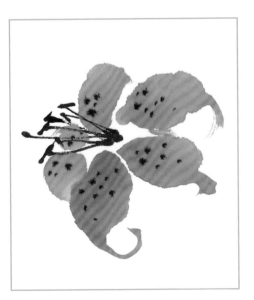

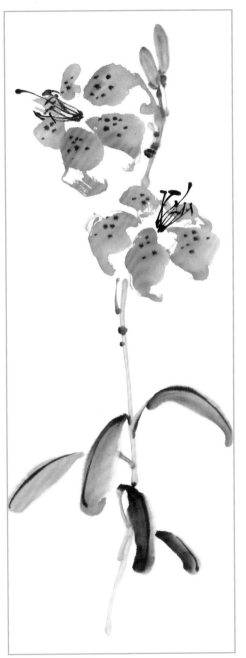

Leaves

Rinse and load your brush with green, then light ink, then dark ink. Use more dark ink for the darker leaf and less for the lighter ones. The hybrid-lily leaf looks similar to a bamboo leaf, except that it has a rounded end instead of a point. Use a pulling stroke and light pressure at the beginning, near the stem, then more pressure in the wider part of the leaf. To finish, don't lift

gradually as you did for the bamboo stroke. Instead, remove the brush from the paper while the heel is still in contact with it. Paint the darker front leaves before the lighter back leaves. A single leaf vein can be added with the small detail brush while the leaves are damp, but not wet.

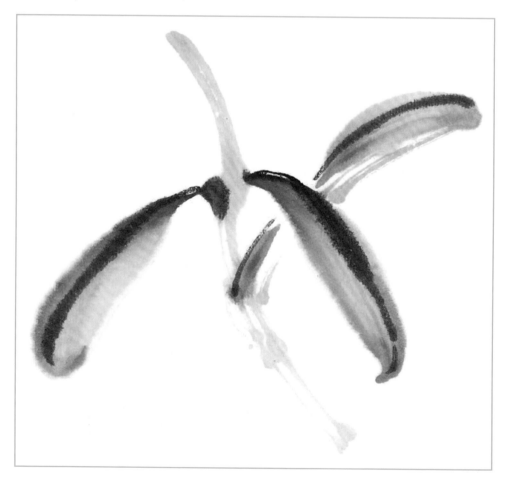

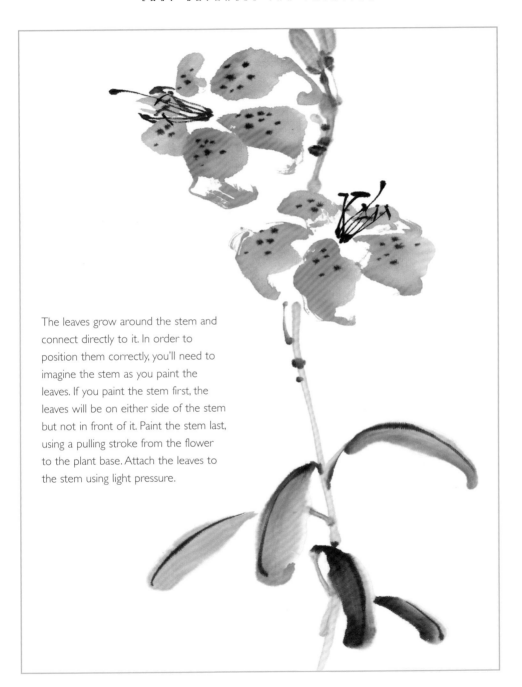

The leaves grow around the stem and connect directly to it. In order to position them correctly, you'll need to imagine the stem as you paint the leaves. If you paint the stem first, the leaves will be on either side of the stem but not in front of it. Paint the stem last, using a pulling stroke from the flower to the plant base. Attach the leaves to the stem using light pressure.

How to Paint
a Rose

The rose is one of the most universal flowers. Nearly everyone can recognize one and knows the scent. If you analyze a rose, either from the side or full on, you'll notice that the petals form angles. Three petals together form a rough triangle.

Think of these angles and triangles when you paint to help you to visualize the strokes.

Rose in Vase, by Susan Frame.

Preparation

Prepare light and dark ink and mix light red, intense red and orange. For the leaves, mix intense green. To paint the flower, load your large brush with light red. Add a little orange and then intense red on the tip.

Flower

Begin with the center of the flower and paint a triangular shape with three strokes, using the intense red on the tip of the brush. The rest of the petals will encircle this triangle.

Using a wet brush, paint side strokes at each point of the first triangle. Curve your strokes a bit to shape the rose. Notice that these last three strokes form another imperfect triangle. Paint more side strokes at each of these new corners. Twist and manipulate the heel of the brush to form interesting petal forms. For a very large rose, you could continue adding side-stroke petals at the corners of each new triangle.

Step 1

Step 2

Step 3

Step 4

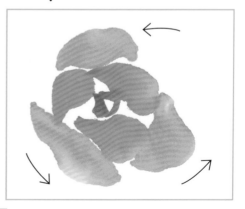

Leaves

To paint leaves, load your large brush with green, then light ink to dilute the brilliance of the color, then dark ink on the tip of the brush. The "generic-leaf" technique is used for the rose leaf and most other leaves as well. To master leaves, paint pages of them using this technique. The generic leaf is painted using two side strokes next to each other. Stagger the strokes, so that one starts higher and ends higher on the paper than the other. When you first practise leaves, your strokes may look very rectangular. As you become comfortable with the strokes, move the brush to curve the leaf. Practise lifting the heel without lifting the tip to create a more pointed leaf. This leaf technique is useful for most plants. Other leaves have different lengths and widths, but the basic stroke is common to all.

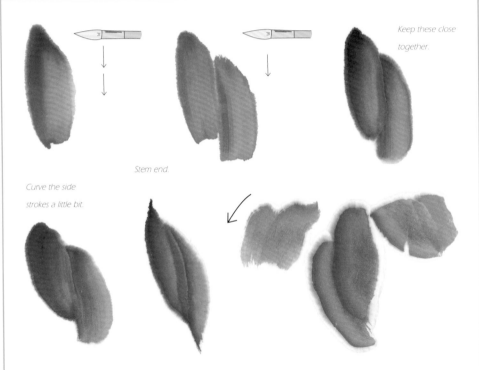

Keep these close together.

Stem end.

Curve the side strokes a little bit.

Rose leaves have three or five separate sections on one leaf stem. Each section is an individual leaf. To be true to the leaf form, paint the leaves in groups of three or five. Paint groups of dark leaves right next to the flower. The contrast of the ink with the colour will accentuate the flower.

Stem

Paint the stem next, using a pulling stroke away from the flower. For a more interesting composition, paint the stem with some angles. Finally, add a light leaf and attach it to the stem.

One central vein will transform your side strokes into an actual leaf.

Leaf Veins

Add the veins with your small brush after the leaves have dried a bit. They should be damp, but not totally dry. Because they are part of the leaf, the veins should bleed into the leaf a little.

Practise painting pages of leaves in all directions.

Add the veins last.

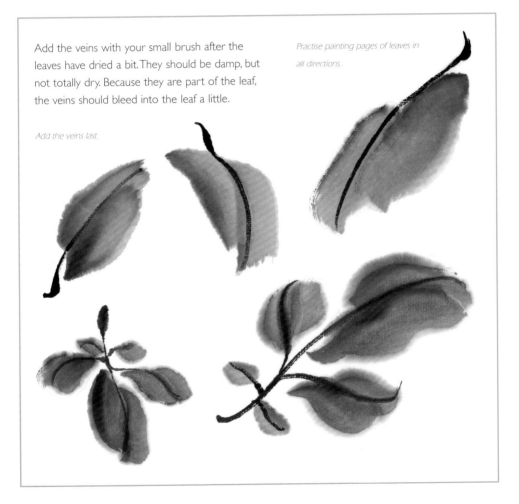

Thorns

To finish the painting, add thorns. Use the small detail brush and dark ink. Holding the brush upright, push down on the tip and pull while lifting abruptly. I call this the "chocolate-chip" stroke.

How to Paint
a Cat

Tommy, by Susan Frame.

susan frame

Cats have been Sumi-e subjects for centuries, probably because they have such unique personality traits. Cats can take you or leave you. They don't seem to need you around, but when you give them attention they purr loudly with pleasure. They can be long-haired, short-haired, or somewhere in between, and fluffy or smooth. Cats can loll about the house or garden without a care in the world or gaze intently at potential prey. Capture the cat personality, and you'll have a successful painting.

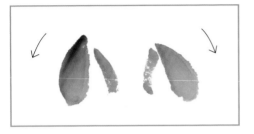

Step 1

Mix dark and light ink, intense brown and orange. Load your large brush with brown, orange, light ink and dark ink. I usually begin with the ears, but you can start with the eyes if you prefer. Use a pulling stroke, beginning at the tip of the ear. Think about your cat: is the ear rounded, very pointed, small, and close to the head, or very large?

Step 2

Next, paint the almond-shaped eyes. Position the pupils towards the bottom of the eye shape because this cat is looking at a mouse.

Step 3

Now paint the nose. Most cats do not have long noses, so the brush dab should be fairly close to the eyes. Using a dry brush, paint the line from the nose to the upper lip. If your cat is happy, the lip lines should pull upwards.

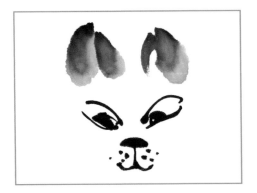

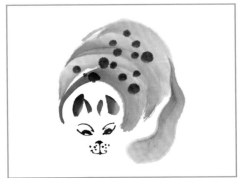

Step 4

Add dots for for the whisker beginnings.

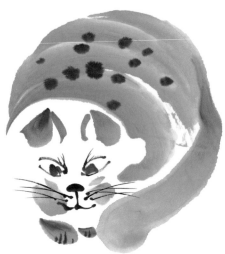

Step 5

Paint the body, using side strokes. Load the brush with brown, orange, light ink and dark ink. Point the tip towards the head and drag the brush in a curved motion around the head. Continue working back with successively shorter side strokes.

Step 6

The tail curls around the body, almost twitching as the cat watches the mouse. Re-load your brush with color and ink, making sure that it is wet and full. Using a combination pulling-side stroke, drag the brush from the back of the cat around the body, towards the face. Push the heel of the brush into the paper at the tail's widest part.

Step 7

Dab the brush under the face to represent the paws. Also dab light color on to the cheek area to fill out the face. While the paws are damp, use a dry brush to paint the toes. Wait until the cheeks are dry, then use a very dry, small detail brush to paint the whiskers with smooth, even strokes.

A Mouse

A mouse is an easy addition to a cat painting. Load your brush with brown, light ink and dark ink. Hold the brush upright and lay the tip and heel on the paper to paint the head. This is the same stroke as for a bird head (step 1). Re-load the brush and paint a curved side stroke, beginning at the back and dragging down, towards the bottom (step 2). Re-load the brush, make sure that it is dry and pull the tail stroke from the body out to the tip. Add the eyes, nose and whiskers with a small, dry brush (step 3).

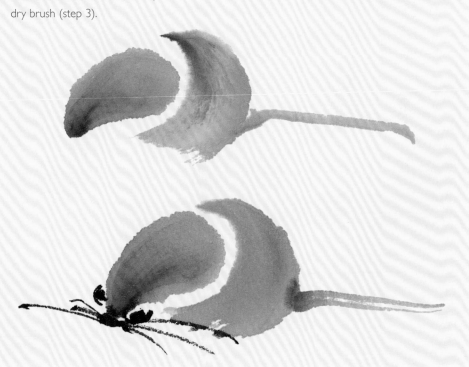

How to Paint
a Scottie Dog

Dogs of all kinds make great painting subjects. If you don't have one, it will be easy to find someone who does.

Scotties lend themselves very well to Sumi-e because of their distinctive shape. Scotties are black, wheaten or brindled, but I usually paint them with black ink only.

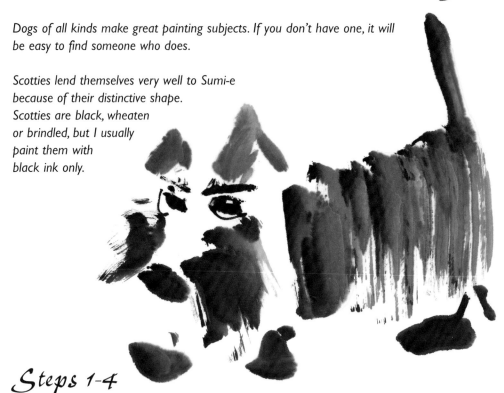

Steps 1-4

Load your large brush with light and dark ink. Paint the ears first with pulling strokes, beginning at the tips (step 1). I often paint the nose next, but if you prefer, you can paint the eyes and then the nose. Scotties have very large heads and long muzzles in proportion to their bodies, so the placement of the nose is important. Use your large brush and dab the tip to paint the nose (step 2).

For the eyes, load your small brush with dark ink and paint the pupils. The line around the eyes is done with a dry brush. Use dark ink on the large brush for the bushy eyebrows (step 3).
One of the unique characteristics of a Scottie is the side hair on the face. Use a fairly wet brush and fast side strokes, beginning at the nose and working back, towards the eye (step 4).

Step 1

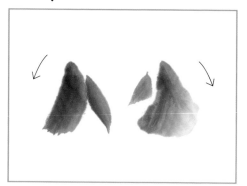

Step 2

Step 3

Step 4

Step 5

The body is also painted with side strokes. Your brush should be quite wet, loaded with tonal variation. Work from the head back to the tail. Tails that stand straight upright are another identifying characteristic of Scotties. Paint the tail with a pulling stroke, beginning at the tip and coming in to the body. Finish the painting by giving the dog some paws. Use a large brush and a pulling stroke.

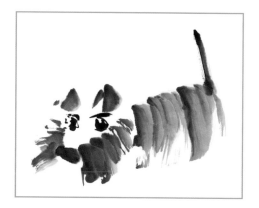

How to Paint Frogs

Frogs are difficult to study because they seldom stay still. So think about their actions and croaking sounds as you try to capture their personalities.

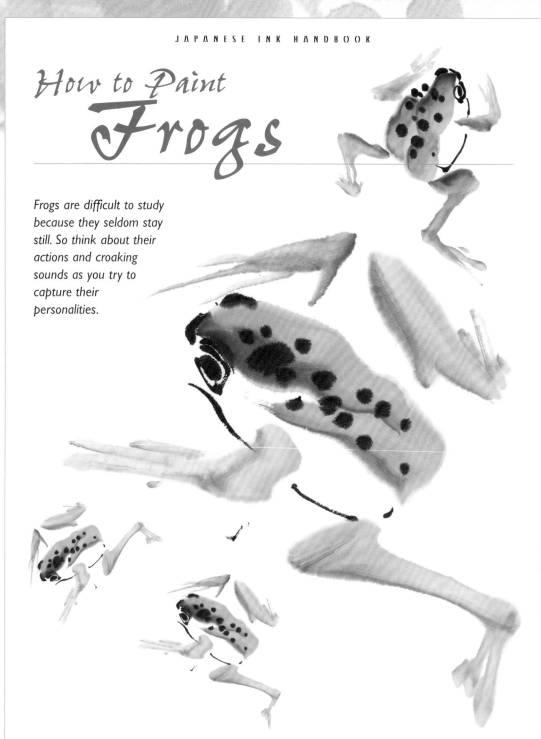

Step 1

Prepare both light and dark ink and mix intense green. Paint the head and body with one pressure stroke. Begin at the mouth, with just the tip of the brush, then push the heel down for the wider parts of the head and body.

Step 2

Add a second stroke next to the first to make the body fatter.

Steps 3-5

One of the keys to painting frogs successfully is their legs. The position of the legs can give a sense of movement and vitality. Paint the back legs using a combination side-and-pulling stroke. Begin near the body with a side stroke, and at the first joint turn the brush and pull it towards the foot. Stop at the ankle. Use pulling strokes from the toes to the heel to paint lines representing the feet. The front legs are painted in the same way as the back legs, using a combination side-and-pulling stroke.

Step 6

When your frog has full body movement, paint its eyes with a small detail brush and black ink. A black line is all that you need for the mouth. Finish the frog with a line that fills out the breast, going from the eye to the back leg.

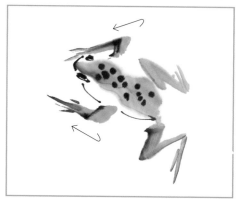

How to Paint
Vegetables

Vegetables are the most interesting when you use real models. Pick up some peppers, mushrooms, radishes, garlic, bok choy and whatever else catches your eye when you're at the supermarket.

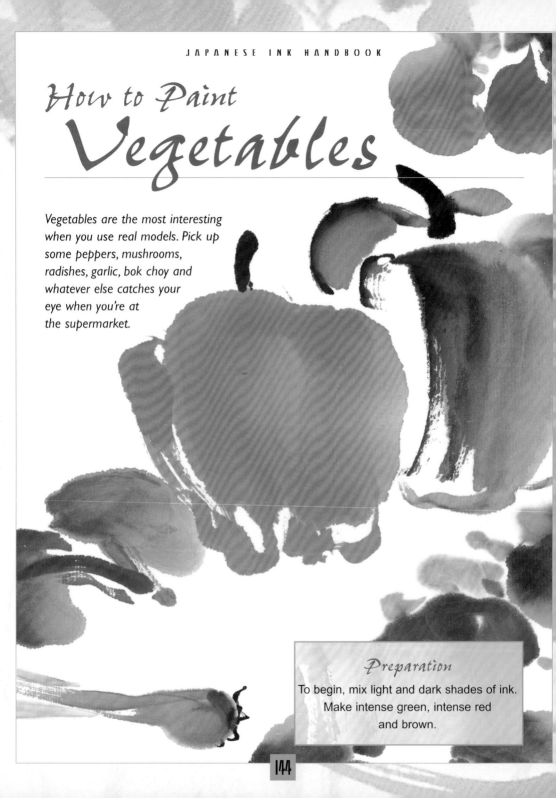

Preparation

To begin, mix light and dark shades of ink. Make intense green, intense red and brown.

Green Peppers

To paint green peppers, load a large brush with green, light ink and dark ink. Beginning at the stem, use a side stroke to paint the shape of the pepper. Leave some areas white and finish the form with a dry brush line. Continue with smaller side strokes as you work your way around the pepper.

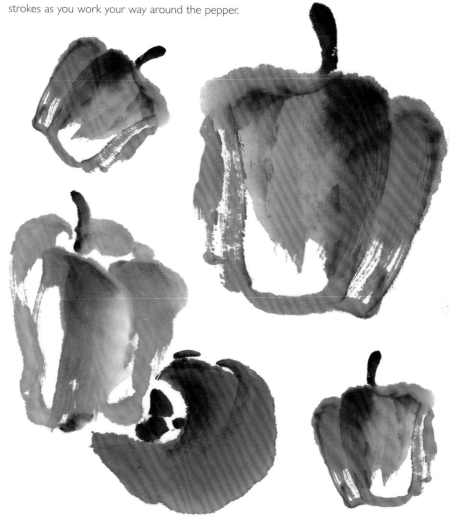

Mushrooms

For mushrooms, load a large brush with brown, light ink and dark ink. Begin with the mushroom cap, then paint the stem.

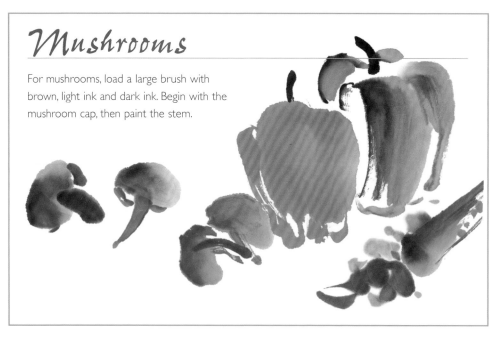

Radishes

Paint radishes with a smooshing stroke. Load your brush with light and intense red and move the heel on the paper to create the circular shape. Using green, light ink and dark ink, paint small pulling strokes for the leaves.

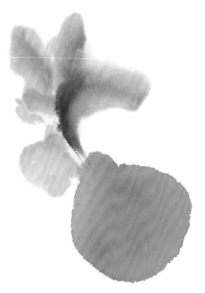

Garlic

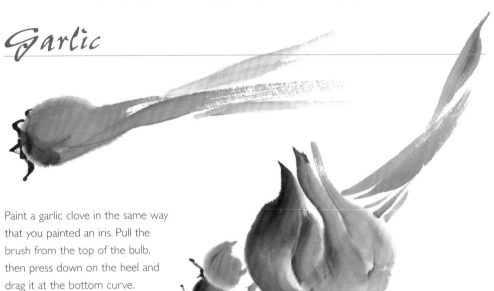

Paint a garlic clove in the same way that you painted an iris. Pull the brush from the top of the bulb, then press down on the heel and drag it at the bottom curve. Pulling strokes are also used to suggest the other cloves.

Bok Choy

Pak choi has white, crisp stalks and large, leafy greens. Use side strokes, one next to the other, to paint the leaves. Paint some leaves, then some lines for the stalks, then more leaves to build the form. Try to put tonal variation into the line work. If your ink and color tones are beautiful, you won't need to add veins to the leaves.

How to Paint
Grapes

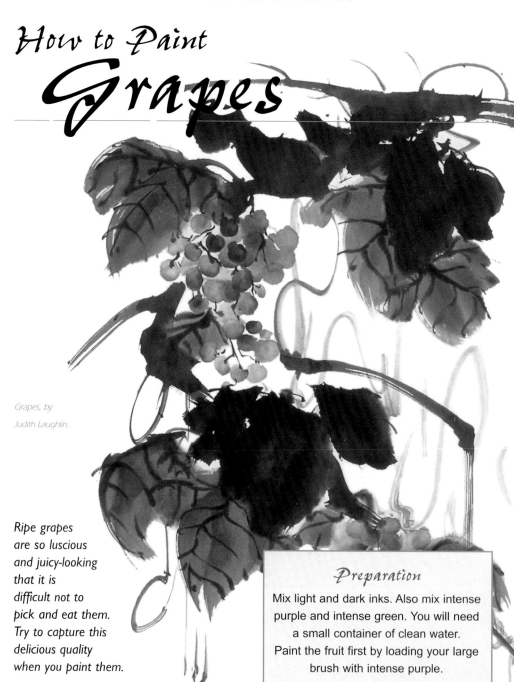

Grapes, by
Judith Laughlin.

Ripe grapes
are so luscious
and juicy-looking
that it is
difficult not to
pick and eat them.
Try to capture this
delicious quality
when you paint them.

Preparation

Mix light and dark inks. Also mix intense
purple and intense green. You will need
a small container of clean water.
Paint the fruit first by loading your large
brush with intense purple.

Grapes

Dip the tip in clear water. Paint the grape with a smooshing stroke by placing the tip of the brush on the paper and moving the heel to form the circle. Don't worry if the grape is not a perfect circle. You can always fill in the shape with an additional line.

Paint front grapes darker and back grapes lighter. Paint partial grapes when one is behind another. Position each grape to add to the shape of the hanging cluster. For interest, paint some leaves in front.

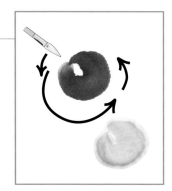

Leaves

To paint leaves, load the brush with green, then load it with light and dark ink. Leaves are painted in sections, using two side strokes next to each other in the "generic-leaf" manner (see page 69). Grape leaves are large and wide. Paint each stroke with a full, wet brush.

While the leaf is still damp, add veins using a small detail brush.

Paint the branch using a side stroke with light and dark ink. Although the grape plant is a vine, the branch can be quite woody. If the leaves don't look attached, connect them with a line from the leaf stem to the branch.

The grape cluster hangs from the branch and the individual grapes are attached to a main stem. Try to put tonal variation into your fine line work. Finally, add curling tendrils using a dry brush.

149

How to paint
Morning Glories

Morning's Glory, by Kay Stratman.

Morning glories have heavenly colors of azure, lavender, pink, magenta, burgundy, and white. They bloom in the morning and have faded by the afternoon. Their vines climb up a trellis or twist through a garden fence.

Preparation

Mix light and dark ink. You'll also need white gouache, intense blue, green and intense yellow. To paint the flowers, load the large brush with white gouache and blue.

Avoid the "candy-stripe" effect of brush-loading by moving the brush across a plate to blend the colors together.

Step 1

For a full-face view, use side strokes to paint the five sections of the morning glory. Point the brush towards the outside edge of the flower, with the heel in the center, and drag it sideways. Begin the next petal stroke at an angle to the first one. Paint five strokes around the flower center. Using intense blue, paint the petal lines with the tip of your brush. Wait until the flower is dry before painting the center, using white gouache and intense yellow dots.

Step 2

To paint a side view, point the brush towards the top of your paper and drag it. Paint partial petals behind this one with small side strokes. The flower funnel shape is easily seen in this view, so paint it with a couple of pulling-stroke lines.

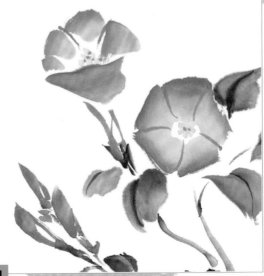

Morning glory Leaves

Morning-glory leaves are heart shaped. Use the "generic-leaf" technique (see page 69) and twist the heel of the brush a little to curve the top of each stroke for a heart shape. To make the leaf pointed, drag the side stroke while lifting up on the heel of the brush until only the tip is in contact with your paper. While the leaf is damp, but not wet, paint the vein with your small detail brush.

Step 3

After painting the flowers and leaves, paint the stem using a pulling stroke from the flower to the base of the plant. Attach the leaves and flowers to the stem if necessary. Morning glories are rambling vines, with small, climbing tendrils that reach out to catch whatever is near. Paint the tendrils with dry, quick, pulling strokes. If, when you've finished, your painting looks a little dull, add a few dabs of magic green to the base of the plant and some dots to the flower centers. Be sure to think carefully before you place this colour, otherwise it will overpower the rest of the painting.

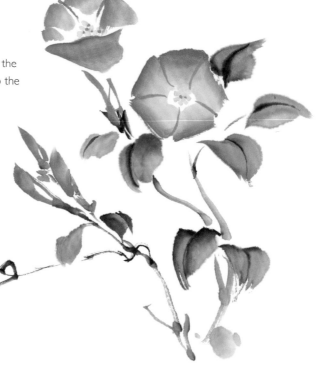

How to Paint
Peonies

Peonies are soft and fragrant. They have a relatively short season, blooming for only a couple of weeks in early summer. Single peonies have one layer of petals, while double peonies have many petals, making them look fluffy. Tree peonies with woody stems are often painted in Asia, but herbaceous peonies that dip to the ground with the weight of their blooms are the norm in northern climates. Peony colors are red, maroon, pink, cream, white, yellow, and violet.

Peony, by
Susan Frame

Preparation

Mix light and dark ink. Also mix white gouache, intense red, green, intense yellow and magic green.

Steps 1-2

Paint the flower using smooshing strokes for the petals. First, load the large brush with white gouache. To show the softness of the petal, your stroke should be wet, so don't blot your brush much. Next, load red on top of the white. Blend the brush on a separate plate to force the colors together and to avoid the "candy-stripe" effect. Be careful not to blend too much, or you'll have a solid pink. Begin with the bottom petals. Lay your brush down and pull it while smooshing it to the side. Then lift it off the paper.

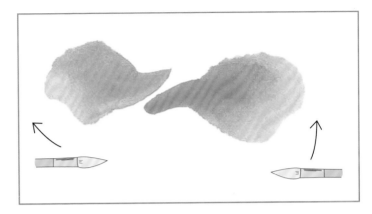

Steps 3-4

The white space above those two petals will be the center of the flower, and the other petals will surround that space. Paint two petals above the space, using the same smooshing technique.

Adjust the pull and side motion of the brush to change the size of the petal. The darkest part of the petal points to the center of the flower, which means that the tip of the brush is pointing to the center.

Step 5

Paint a fifth petal on the side of the flower.

Step 6

Now work your way around the flower, adding petals where needed. The tip of your brush will fit in the white spaces between petals. Use the smooshing technique with a wet brush to create the softness of the petal. Be sure to use intense red on the tip of your brush so that there is a contrast difference between the edge of the front petal and the petal behind it.

Step 7

Develop the shape of the flower by adding petals. Strive for an interesting shape, with uneven edges. After finishing the petals, add a very light green wash to the central white space of the flower by pressing the brush to the paper and allowing the color to run a little.

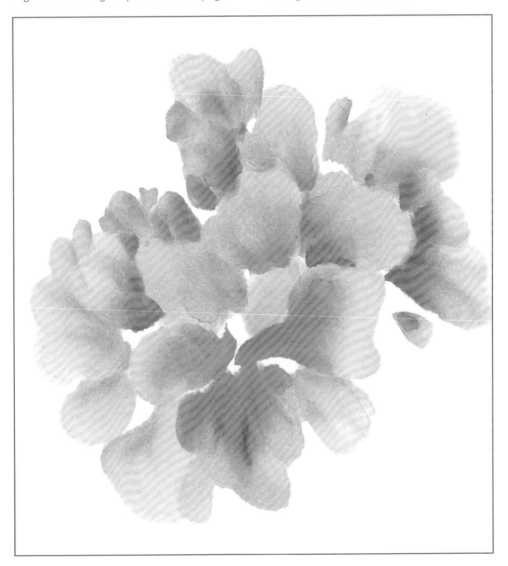

Leaves

After the main flower, use a large brush loaded with green, light ink and dark ink. Peony leaves have three or five long, heavily veined lobes on one leaf stem. Use the "generic-leaf" technique (see page 69), one long side stroke next to another one, for each long lobe. Paint some dark leaves next to the flower to emphasise the light flower color. While the leaves are damp, paint the veins using a small detail brush and a light touch. Paint the central vein first, then add the side veins. Pay attention to the connection of each line because the veins are the skeletal structure of the leaf. They give visual definition to what is otherwise a nondescript stroke on your paper.

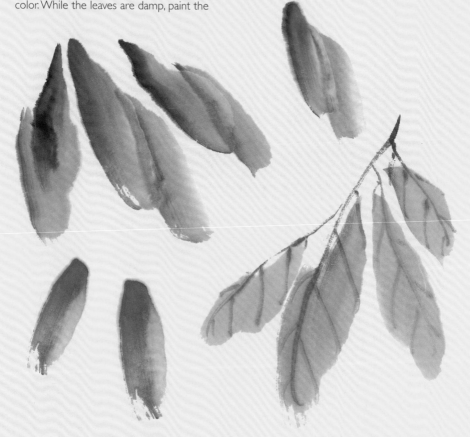

Buds are painted with a smooshing stroke. Begin at the tip of the bud, push the heel down and pull it to the side.. Add a second stroke next to the first to fill it out. Paint the calyx using a pressure stroke.

Paint the stem after the leaves, using a pulling stroke. Use shades of light and dark ink, or begin with green and add light and dark ink.

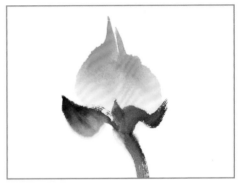

The flower center is painted last, on top of the green wash in the center. Load your small detail brush with intense white and intense yellow. The white should be quite thick and opaque so that the strokes will show when painted on top of the color. Using a small pressure stroke, paint a stamen by pushing with the tip of the brush, then lifting and pulling to the center of the flower. Use a little magic green here and there to help to draw your eye from one spot to another.

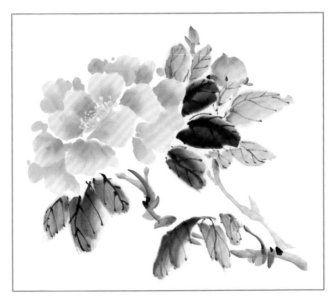

159

How to Paint
Tulips

Tulips, by
Susan Frame

Preparation

To paint tulips, mix light and dark ink, light
and intense purple, white gouache, intense
yellow, green, and magic green.

In northern climates, tulips are synonymous with spring. Their joyful colors bring great inspiration after the dreary winter. Tulips are frilly or smooth, large or small, long-stemmed or short-stemmed, but they are all basically the same shape.

Step 1

To paint tulips, load your brush with light purple and tip it with dark purple. Use two side strokes to paint the first petal. Lift the heel of the brush as you reach the end so that the bottom of the petal is narrower than the top.

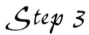

Step 2

To keep your brush replenished, you'll need to re-load it for each petal. The second petal is opened up and is also done with a side stroke. Begin at the tip of the petal and drag towards the flower.

Step 3

Do the third stroke in the same way on the other side of the flower.

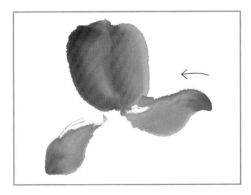

Steps 4-6

The fourth and fifth petals are behind and peeking out. Use lighter color for them. To finish the flower, use your small brush to add a vein down the center of the first petal.

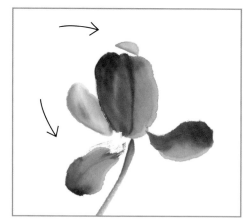

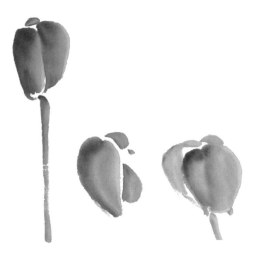

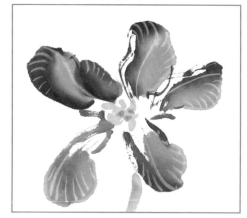

All of the different views of the flower are painted using this side-stroke technique. Manipulate and twist your brush to create the curves in the petals. The stamens are out of sight unless the flower is fully open. To paint the six stamens, use a small brush loaded with white and intense yellow. Use a little pressure for the pollen-laden cap of the stamen. It also has one creamy, short pistil, which you may or may not see.

You may want your flowers to look frillier, with lacier edges. If so, add veins along the edges of the petals. Do this with a small, dry brush while the petals are still damp. Think about the curve of the petal as you paint these lines.

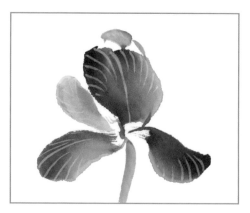

Leaves

Leaves are painted with long, combination pulling-side strokes. Load your brush with green, then light ink, then dark ink. Begin at the plant base with a pulling stroke. As the leaf widens, turn the brush, continuing with a side stroke. Taper the end of the leaf by lifting the heel. Go back to the beginning and repeat the same technique, laying a second stroke next to the first one. While the leaves are damp, add the main central vein. Paint some leaves darker and some lighter to create interesting depth in your composition. At the end, dab on magic green to add extra sparkle to your painting.

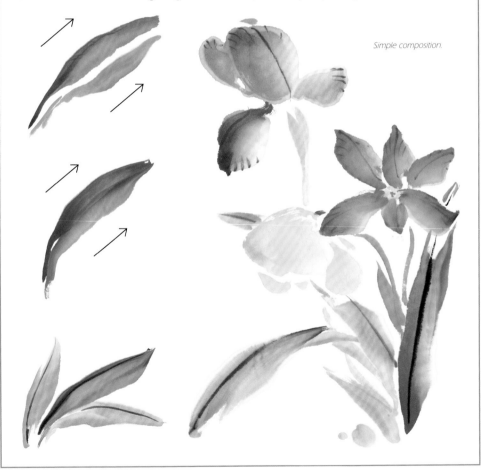

Simple composition.

How to Paint Hibiscuses

Hibiscus,
by Susan Frame.

Hibiscuses are spectacular flowers that bloom in a variety of colors and sizes. At botanical gardens, I've seen nearly every color: red, orange, yellow, maroon, lavender, rust, red so deep it's black, white, pink, even blue, and all of the shades in between. Small blossoms are the size of the palm of your hand, while large blossoms can be as big as a dinner plate.

Preparation

Light ink, dark ink, white gouache, intense yellow, brown, orange-red, green, and magic green.

Begin with the flower. Load your large brush with white gouache and intense yellow and color the tip with brown.

Hibiscuses are single, with only five petals, or double, with a profusion of beautiful petals turning this way and that. The leaves also vary a great deal in size and shape. Some plants have roundish, pointed leaves, others are elongated. All hibiscuses have sturdy stems and branches, but the shrublike plants have woody stems and the small, potted varieties have smaller, thinner stems.

Steps 1-4

Paint the hibiscus petals using the technique for tulips: side strokes that pull from the outside of the petal into the center of the flower. Each hibiscus petal consists of two or three side strokes, depending on the shape. Vary the starting position and curve the stroke for an interesting petal form. As you near the center, taper the stroke by lifting the heel of the brush. You will probably have to re-load your brush for every stroke. The petals should look saturated and full. When the flower is damp, but not wet, paint the petal veins with a small brush. You may use either white gouache or a darker color, whichever you prefer.

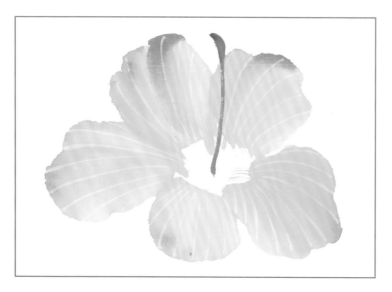

Step 6

Add the pistil with your small brush by painting five red-orange dots and connecting them to the stamen with a very light touch and a dry, small brush.

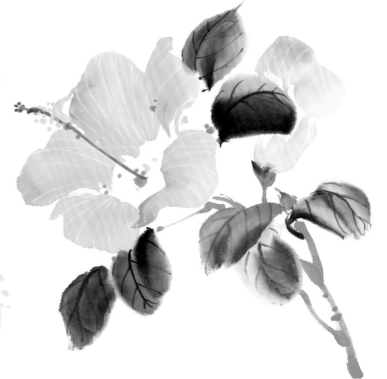

Generic-leaf Technique

Paint the leaves after the main flower. Use the "generic-leaf" technique (see page 69) to paint the form. The leaves alternate around the branch, so paint them in groups. Paint the leaf veins while the leaves are damp, using a small brush. Paint the central vein first, then the side veins. Work from side to side, from the stem end of the leaf to the tip. Paint the branch with a pulling stroke and then attach the leaves to it. For a little color contrast and interest, dot the painting with magic green.

How to Paint a
Bird of Paradise

*Bird of Paradise,
by Susan Frame.*

The bird of paradise is a dramatic flower that blooms in southern climates. In full bloom, it resembles the head of a bird with beautiful plumage.

Preparation

Mix shades of ink, purple, blue, green, orange, intense red, and light yellow.

Step 1

A pressure stroke is used for the green flower casing and stem. The casing holds the flower petals and, as the flower opens, the petals rise out of it. Load a large brush with light green, intense green and a little purple. Begin at the tip and pull towards the stem, exerting more pressure as you go. At the end of the stroke, push with the heel of the brush, then turn and curve, like a backwards-pointing letter "C". Lift your brush, set it down at the curved end of the stroke and pull down for the stem.

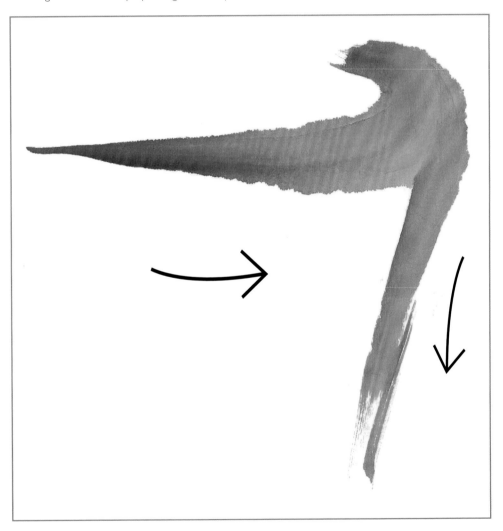

Step 2

For the flower, load your large brush with orange and red. I usually paint each petal from the tip into the center of the flower, but you should experiment to find out which direction is comfortable for you. This stroke is the same as for a long bamboo leaf. Begin with just the tip of the brush, exert pressure for a wider stroke as you continue pulling and then lift again where the petals join at the base.

Step 3

To keep your painting interesting, vary the color of the petals a little bit. Try loading light yellow first, then orange for lighter petals. You could also use light orange first, then intense yellow. There is no set number of petals, so paint as many, or as few, as you like.

The flower not only has orange petals, it also has a blue, or blueish-purple, one. Load light blue and then purple on the brush. Using just the tip, pull in towards the center of the flower. The petal widens out into a heart shape in one area, so push the brush tip down a bit at this spot, then lift and continue to the end of the petal.

Leaf

The leaf is painted last. The bird of paradise has quite a few large leaves, but if you paint them all, the leaves will overshadow the flower and the painting will be less dramatic. Again, use a large brush loaded with green, light ink and dark ink. Begin the side stroke at the base of the stem and pull the brush out, towards the tip of the leaf. Lay down a second side stroke next to the first to make the leaf wider.

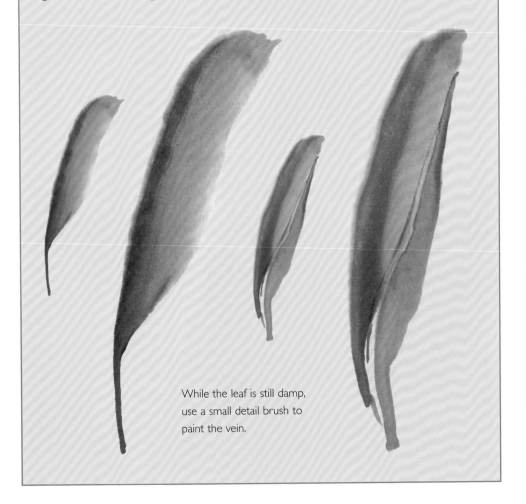

While the leaf is still damp, use a small detail brush to paint the vein.

How to Paint
Narcissi

Narcissi bloom early in spring, while the weather is still chilly. Their bright-yellow and white petals look gorgeous against the new green grass. Both narcissi and daffodils have trumpet-shaped centers surrounded by six petals.

Steps 1-2

To paint narcissi using the outline technique, load a large brush with both light and dark ink. Dry it well because you want thin, not thick, lines. Begin with pulling strokes to paint the central trumpet. Paint the oval first, then lines from the oval to the flower center.

Steps 3-6

Paint the petals with two pressure strokes, one on each side, pulling in from the tip of the petal to the center of the flower. Use a little extra pressure on the tip. It is important to make lively strokes when painting in the outline method. It's very easy to become so engrossed in painting perfect shapes that energetic brushwork is completely neglected.

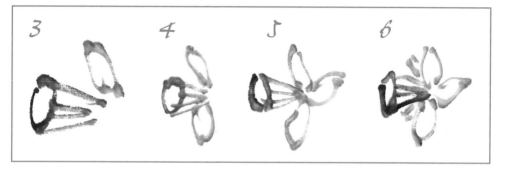

Step 7

When the flowers are dry, mix a light wash of color and apply it to each petal in one brush stroke. Don't try to fill the lines completely with color. It is fine if the color bleeds outside the line.

Add a little vivid color in the center of the oval trumpet to define the flower center. Paint the leaves using pulling strokes without a severely defined point.

While the leaves are still damp, add the central vein.

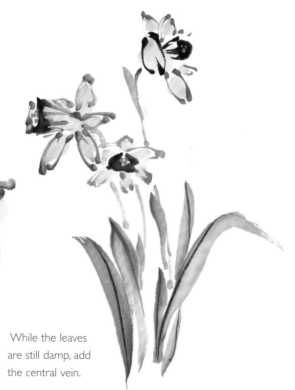

How to Paint Birds

Birds are wonderful subjects for Sumi-e because they're so animated. Your Sumi-e skill will be tested as you try to capture their lively energy with your brush and ink.

There are many kinds of bird, but most of them can be painted using variations of just a few strokes. The basic bird technique consists of a pressure dot stroke for the eye, a pressure stroke for the head, two side strokes for the body and pulling strokes for the tail, legs and beak.

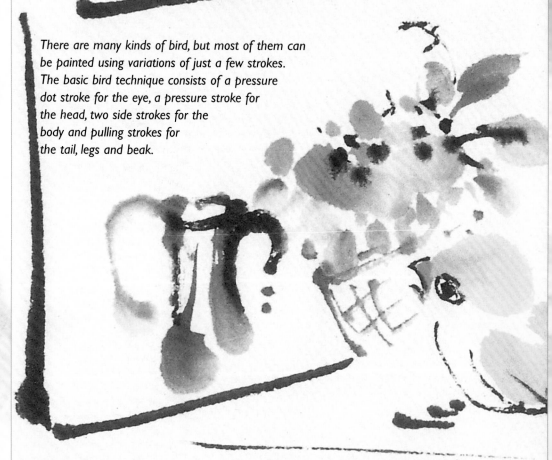

Real Life, Still Life, by Susan Frame.

To begin, think about what kind of bird you're painting, and about what it is doing. Is it large or small? What shape is the body: round and puffy or sleek and long? What shape is the beak? How long are the legs? What does it eat? Where does it live?

In this demonstration, we'll paint a sparrow. Sparrows hop around on the ground a lot and have short legs. They flit from here to there. Their colors are brown, gray, black, and white. Their beaks are short and stout because they are seed-eaters. They chirp and sing and seem happy. You can think about all of this as you grind fresh ink.

Step 1

Prepare both light and dark ink and mix brown using burnt sienna. Also mix yellow with a touch of red in it. Some painters believe that you have to start with the eye to establish the character. I think that it is easier to begin with the head and body, then fit the eye and the beak to the head. The order really doesn't matter, so do what works for you. Using a large brush, load brown, then light ink, then dark ink. Hold the brush upright and push down on the tip to paint a tear-shaped stroke for the top of the head. If your bird has a larger head, pull the brush a bit as you exert more pressure.

Steps 2-3

Paint the body with two side strokes. Lay them side by side. Remember that these strokes are not intended to be a literal representation: they are intended to characterise the body. Therefore you're not trying to paint strokes that curve like the back of the bird or that look like wings. You're only interested in painting two side strokes with nice tonal variation. Try to paint them near the head.

Step 4

Next, paint the tail by using two pulling strokes. Think about what the bird is doing when positioning the tail.

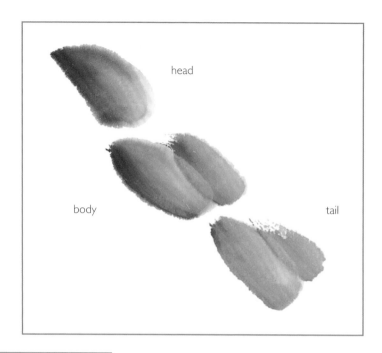

head

body

tail

Step 5

Stop a minute and take a look at your painting. It just looks like five ink blobs, doesn't it? This is the magic moment when the details turn your blobs into birds. Load a small detail brush with dark ink and blot it well. Paint the eye with the tip of the brush, then paint a fine line around the eye. Don't try to make a perfect circle. It is often more interesting to paint the circle shape with two strokes instead of one. Pay attention to where the black dot is placed within the circle because the eye adds a lot of personality to the bird. In fact, a useful exercise is to paint pages of eyes, all placed differently within the circles. You'll discover how to paint birds that are angry, mean, cheerful, happy and so on.

Step 6

After the eye, paint the beak with dark ink. Dry your brush well and pull it from the tip of the beak to the head. Paint the top line first, then the bottom. Go slowly to control the direction. When you're finished, the head stroke should be on top, with the eye stroke under the head stroke, centred approximately between the top and bottom of the beak.

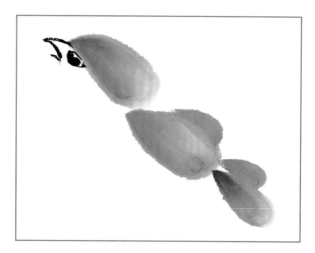

Step 7

Paint the breast using light ink and a pulling stroke. Begin near the beak and end near the tail. This stroke establishes the shape of your bird. If your bird is round and puffy, maybe a baby, curve the stroke a bit.

The legs come next. The main thing to remember about birds' legs is that the knees bend backward. Using light ink and a pulling stroke, begin near the body and end at the foot. Stop the stroke and exert a little pressure where the leg bends, then continue on to the foot. Use pulling strokes and light ink with which to paint the feet.

Finally, use dark ink to paint the wing lines. These lines do not necessarily follow the edge of the body strokes. Paint them while the body is still damp so that they'll blend together a little.

I often add a little color to the beak after the bird is completed. If the bird is alone on the page, color is not as necessary, but if there is more action, or a lot of foliage, the beak color helps the bird to stand out. After the beak is totally dry, load a small brush with the yellow-orange colour, blot it well to remove excess moisture and paint the colour in the beak. Do not carefully colour in the lines. Just lay the color down, let it bleed a bit and that's it.

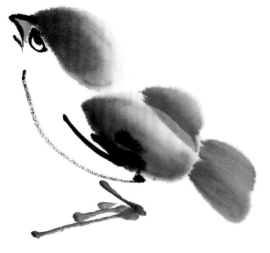

How to Paint a
Great Blue Heron

Long-legged water birds are found
around the world, wherever there is
water. Herons are especially entertaining
to watch because they run back and forth,
flapping their wings, while they chase fish.
They can also stand stock-still, staring intently
at the water, before moving with lightning
speed to spear their food.

With Intent, by Susan Frame.

Preparation

To paint the great blue heron, prepare
light and dark inks and mix a plate
of intense blue.

Step 1

To paint the body, load your large brush with
dark-blue, light ink and finally black ink on the
top. The head, neck and breast are painted in one
continuous stroke. Begin at the point where the
beak touches the head, exert some pressure on
the brush so that the stroke is a little wider at
the middle of the head and pull in an "S" shape
to create the neck. As you round the corner into
the breast, turn your hand and use a side stroke
for the rest of the stroke. Lift the brush without
tapering the stroke.

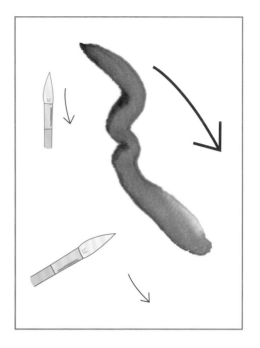

Step 2

Re-load your brush with colour and ink and use a
side stroke with which to paint the back. Drag
the brush past the breast stroke to create the
impression of tail feathers.

Step 3

Paint the eye next with your small brush and dark ink. Paint the line around the eye with a very dry brush to avoid the ink bleeding. After the eye, paint the beak with a dry brush. Begin at the tip and pull the stroke towards the head. The eye should be approximately in the middle of the top and bottom beak strokes. If necessary, add a little finishing stroke to fill out the head from the eye to the neck.

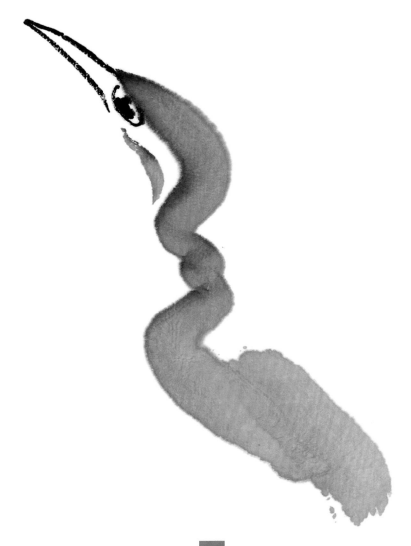

Step 4

For the legs, load your brush with light ink and dark ink. Begin in about the center of the bird, or a little forward, and pull down towards the foot. Stop for the knee joint and continue to the ankle. Paint the toes without detail, using pulling strokes. The second leg is painted bent because the heron often stands on one leg. Remember that the leg bends backwards as you pull the brush from the body to the knee, then switch directions and pull to the front of the bird. Stop and add toe strokes.

Step 5

The finishing touch is the wing stroke. Use dark ink with pulling strokes to paint the lines representing feathers. Remember that you are painting the suggestion of feathers, not the details. Add the wing-feather strokes while the bird's body is still damp.

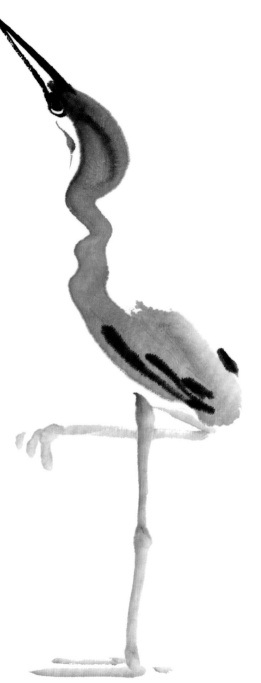

How to Paint Rocks
and Mountains

You can use the same techniques to paint a rock or a mountain. The only difference between them is size. First, think about the rock. What shape is it? Does it have sharp angles or jutting edges? Is it smooth or rough? Adjust the amount of liquid on your brush and the speed of your stroke depending on the shape and texture of your rock.

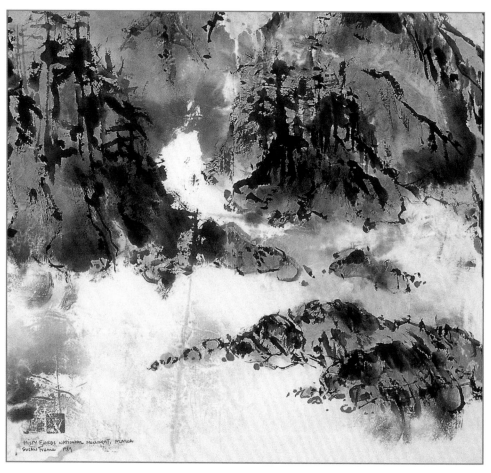

Misty Fjords, by Susan Frame.

Step 1

There are a number of ways to begin the brushwork. You can define a rough shape with line work and then add a wash of color. The line work should be energetic, with varied textures. It may also be broken in places. Add the color wash when the line is nearly dry to prevent any excessive ink bleed.

Step 2

You can also paint a rock by creating the form with a color wash first and then adding defining brush lines. Again, use strong line strokes, with interesting textures.

Step 3

A third way to paint rocks is to use a textured, layering technique. Paint the wash first. While it is still damp, lay a dry side stroke of ink on top of the wash. The dry stroke will diffuse into the wash. The layering technique can also be used with color.

Step 4

When painting more than a couple of rocks, paint some in front and some behind. Create depth by using darker ink for closer rocks and lighter ink for the ones further away, and by leaving white space to separate one rock from another.

How to Paint
Water

Water is usually represented by white space. It is always defined by its boundaries. The land around the water gives it substance and shape.

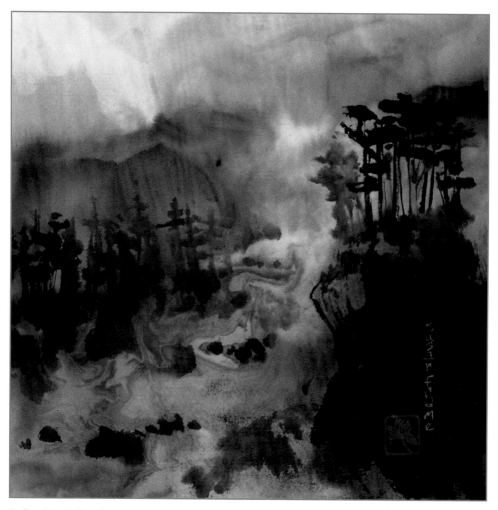

I've Been There, by Susan Frame.

To paint water, paint the land first, using the rock-painting techniques.

Water could be a river, a waterfall, a lake or the sea. If you wish, you can paint lines to show ripples or currents or small rocks to help depict the flow.

How to Paint
Clouds and Mist

Clouds and mist can also be represented by white space. Sometimes it is unclear whether the white space in a painting is sky or water.

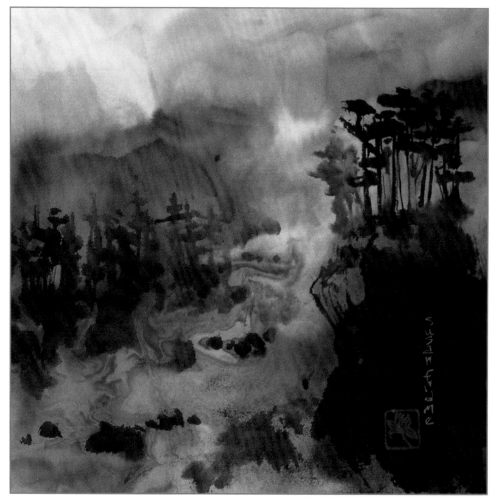

I've Been There, by Susan Frame.

To paint stormy clouds, load your large brush with both light ink and dark ink. Using the side of the brush, twist, turn and roll the brush across the paper. To create layers of clouds, add more strokes, using the same technique. Avoid monotony by varying the shape and length of your strokes.

Mist is painted using a wet brush loaded with very light ink. The tip should be a little darker. Hold the brush so that the tip is pointing downwards on the paper. Paint many little strokes, one next to the other, by laying the brush tip down, then picking it up and moving on to the next stroke, laying it down, picking it up and so on.

If the mist or clouds are in front of a mountain, paint the mist or clouds first and the mountain second.

How to Paint
Trees

There are many different kinds of tree and many ways to paint them. No matter which technique you use, always try for tonal variation in your strokes. To begin, look at trees from a distance. Notice how the overall form varies. Some trees are roundish, others oblong, some triangular. Now look at the shapes within the trees. The variations of color and leaf pattern create a variety of shapes within one tree. When you paint, try to portray these characteristics.

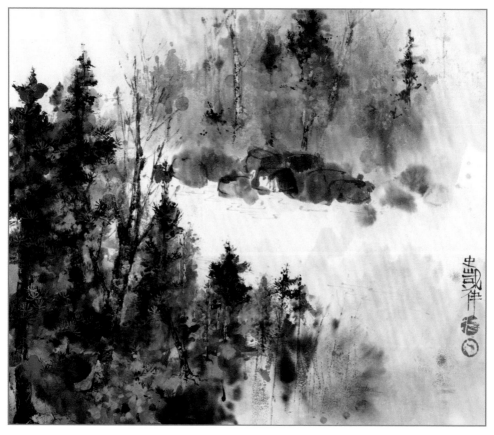

Lake Itasca, Headwaters of the Mississippi, by Kay Stratman.

Deciduous trees are often painted with round strokes, either as circular brush strokes or with outlines. Use the tip of the brush to paint these shapes. Trunks can be painted with a single line or with double lines. Paint leafless winter trees with a pulling stroke, beginning at the top of the tree, then add branches. Think about the kind of tree that you're painting. Is it an elm, with a straight trunk and straight limbs? Or is it an oak, with long, thick, curving branches?

Evergreens are painted with side and pulling strokes to interpret their shapes. Some evergreens are very triangular in shape. Others are most notable for the dramatic shape of each branch and needle clump. Some branches hang down heavily, while others appear to have an upward swing. These shapes are apparent even

from a distance. Paint the needle and branch strokes first, then add the trunks with pulling strokes.

When painting a number of trees together, it is a good idea to paint some lighter and some darker. The contrast of shades and colors will help to make your painting interesting.

How to Paint a
Simple Landscape

To paint this simple landscape, begin with the rocks. Load your brush with brown, light ink and dark ink. Use side strokes to paint each rock shape. Be sure to leave white space between each rock. Paint the trees next. Paint the needle clumps of the middle tree first, using shades of green, light ink and dark ink. Then paint the trunk. Be careful not to paint the trunk too dark or it will become the focal point of the painting. Paint the other trees next, working from front to back, darker to lighter.

Paint the mountains with a side brush loaded with blue and light ink. Leave white space between the tops of the trees and the mountains. Also leave space between the front mountain and the back one.

Paint fine-line water ripples with light-blue color and a small brush. To keep the style of the painting simple, don't paint many ripples. When the painting is dry, paint the birds with a small, dry brush.

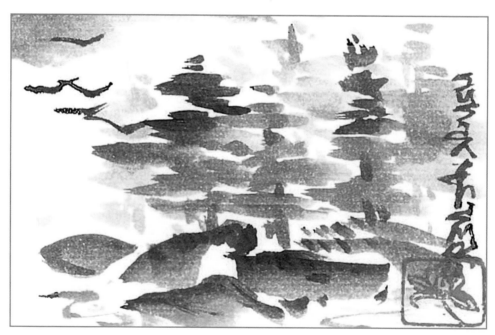

Inside Passage, Alaska, by Susan Frame.

Unpainted White Space

Unpainted space is one of the most important elements of an ink painting. In fact, it is just as important as the painted areas. Brush strokes and their vitality define the shape and energy of the unpainted area. They can contain it or divide it. Without brush strokes, the white paper is just that: white paper. If you can learn to look at the spaces between the brush strokes, not just the strokes themselves, it will be much easier to develop your composition.

If you can learn to look at spaces in the physical world, you will develop your eye for composition. As practice, look at a tree. Now look at the spaces between the branches. Let your eye follow the spaces and use the spaces to determine the shape of the tree. You could also try making a rough pencil sketch of the spaces to illustrate this principle. Draw only the outline of the spaces and you'll see that the tree is defined by them. As with life, you need to look at what's not there, as well as what's there. Look between the lines.

It is not unusual for a flower to be depicted with no visible flowerpot or soil. Sometimes your subjects will appear to float on the paper. White space may represent something literal, like the sky or the water, or something more abstract, like nothingness. You already know that your brush strokes need to be energetic

and expressive of life. If you imagine that your painting needs breath to be alive, then your unpainted area is the breath. The space can be described poetically as the "soul" of your painting. Therefore, for a successful painting, you not only need areas of strong brushwork, but also dynamic areas with no brush strokes.

Between the Trees, by Susan Frame.

Focal Points

Every painting needs a center of interest or focal point. In a simple painting, there is usually one main focal point and other areas that draw your eye, but are secondary. A complex painting usually has a number of areas of interest. Black ink, brilliant color and size are all ways to create focal points. Remember that a focal area may also be the white space or unpainted area.

In Sumi-e, darker or more brilliant colors often represent the most important areas of your painting. They may also represent things that are closer. Lighter ink and colors usually depict less important things or those that are further away. If you are painting a flower in color, one focal-point trick is to use dark leaves close to your main flower. The dark will provide wonderful contrast to the color and will make the flower stand out as the center of interest. Dark-and-light contrast usually does not represent time of day in terms of shadow. Traditionally, little emphasis is given to shadow and light, which are Western concepts of painting.

Size is also used to create focal points. Plan the dominant area

of your painting and then add areas that are less important or subdominant. A flower painting may have one or more flowers and leaves that are dominant and that take up most of the space on the paper. A landscape may have a mountain that is larger or more imposing than the others.

White space is the focal point in Autumn Lake, by Susan Frame.

Variety of Shapes, Angles and Views

The shapes, angles and views of the individual elements of the painting contribute a great deal to its success.

For example, when painting flowers, angle the flowers and leaves in different directions. Paint them from the back, from the side and from the top. In a landscape, the various areas of ink, color or white space should have differing shapes.

Horses in different positions. Horses, Wind and Stormy Sea, by Susan Lasley.

Contrasts

While developing a painting, you should be considering contrasts, not only in individual strokes, but also in the overall composition. Contrasts make your painting interesting. Think about contrasts as opposites that are both necessary to the whole. There are numerous contrasts, but, of course, it's not necessary to use them all in one painting.

If there is too much variation, the painting will feel unsettled. Some examples of contrast are black and white, wet and dry, rough and smooth, thick and thin, large and small, substantial and insubstantial. I'm sure that you can think of many others as well.

Black and White

Black-and-white contrast refers not only to the technique of brush-loading and the individual brush stroke. It also refers to the overall dark and light areas of the total composition. In a painting, the contrast between black and white can be strikingly beautiful. It has been compared with a musical composition, a symphony in black and white, with the shades of ink being the musical notes.

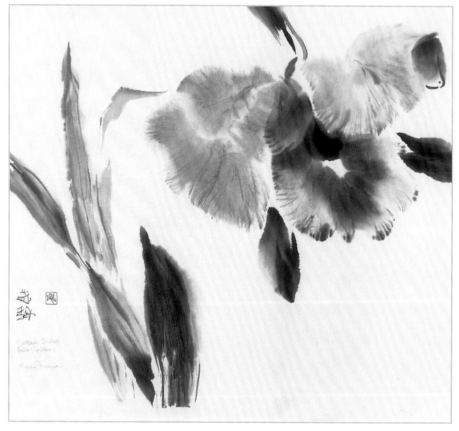

Painting with dark-and-light contrast.

Cattleya Orchid, by Susan Frame.

Wet and Dry; Rough and Smooth

Wet and dry refer to the wet and dry brush strokes that contribute to the overall setting, or ambiance, of the painting. Rough and smooth refer to the texture of the elements in the painting. Rocks can be painted with wet and dry strokes to depict smooth and rough surfaces. You can use a combination of wet and dry strokes to create one smooth or rough surface.

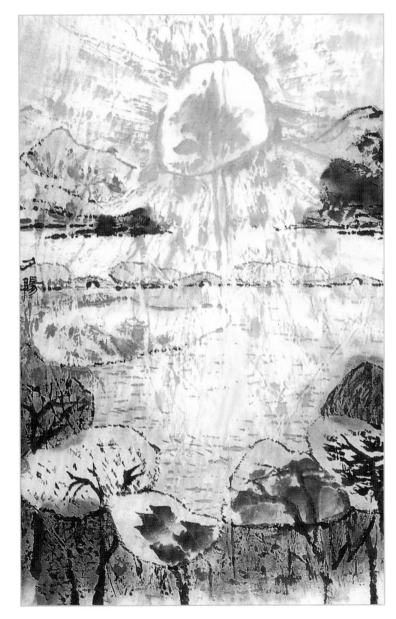

Painting with wet and dry.
Setting Sun,
by Zhuo He Jun.

Thick and Thin; Large and Small

Thick, thin, large and small refer to the size of brush strokes, as well as to the size of the individual parts of the subject and areas of the painting. Just as your brush strokes need variety, so do the individual flowers, trees and rocks. Groupings, or areas, of flowers, trees and rocks also need size variation.

Variation not only adds interest, it can also help to create focal points in your painting.

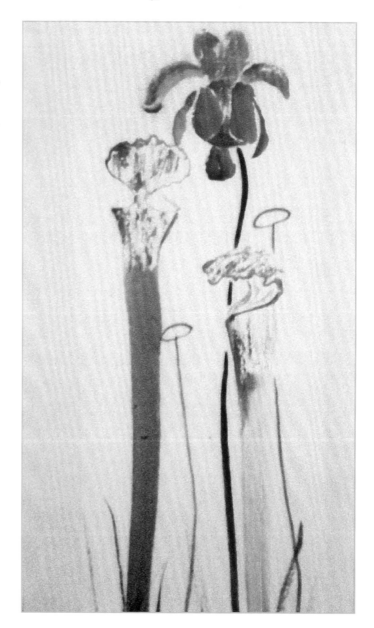

Painting showing size contrast.
Pitcher Plants, by Mary Rodning.

Substantial and Insubstantial

Substantial and insubstantial refer to mass and the heaviness or lightness of the painting. Dark, crowded strokes are substantial, while light, sparse tones are insubstantial. Trees, flowers, and rocks are substantial, while white areas, mist, and clouds are insubstantial.

Insubstantial elements often serve as the backdrop for substantial forms and vice versa. In a well-balanced painting, the substantial and insubstantial elements work together or play off one another.

Substantial and insubstantial.

Winter Breeze, by Sung-Sook Setton.

Position
of Elements

Another very important compositional consideration is the grouping and balance of elements. Where, in all of that open space of white paper, should you place your brush strokes? Certainly, to some extent, it depends on what you're painting. Nevertheless, there are some general rules to follow.

Asymmetry

First, avoid the center of your paper by off-centring your main image. The image should also be asymmetrical. That is, one side of your painted area shouldn't exactly balance the other side.

An example of asymmetry.

Reflection, by Sung-Sook Setton.

Placement

Avoid cutting the paper in half, in any direction, with your brush strokes. This is very easy to do, so watch out. You may paint a beautiful branch and then discover that it goes right up the middle, or diagonally across, the center of your paper.

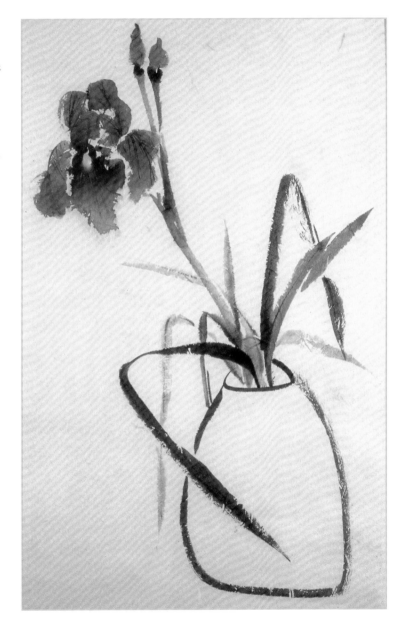

Bad composition, cutting the paper in half – a very common mistake.

Depth

Depth in a landscape painting is shown by placement on the page. The closest mountains are painted first, others are painted behind, becoming progressively higher on the page. In a flower painting, depth is usually depicted by shading. Closer petals, leaves and branches are darker, while lighter ones are further away.

Elements moving upward on the page to illustrate depth.

Mantrap Lake, by Susan Frame.

Color Balance

Color balance is a straightforward concept. If you're working in black and white only, you don't have to worry about it. If you introduce color, you need to think about how one colour plays off another. Colors shouldn't fight one another: they should co-exist peacefully. If they're fighting for your attention, the balance is off. Just like focal points, colors are dominant and subdominant. If there are too many colors in one painting, there are too many cooks in the kitchen. If all of the colors are brilliant, there are too many bosses. Some of the colors have to take back stage, so tone them down with water or light ink or get rid of them altogether.

As a beginner, you're probably safest working with three colors and their light tones. When you're comfortable working with color, you can introduce other colors for more complex paintings.

Nice color balance.

Mountain Village, Guatemala, by Susan Frame.

Movement and Balance

Space creates movement and helps to lead the eye through the painting. The ebb and flow of the white space in and around the brush strokes draws your attention from one part of the painting to another, providing transition. Transition enables the viewer's eye to move easily around the painting. The direction of lines and the use of related colour in various areas of the painting also contribute to transition.

Dots have a special place in composition. They can also be used for esthetic purposes, to draw attention to a specific place, or to draw attention away from another place. Dots force the viewer's gaze to move around the painting. With good transition, your composition will look like one complete painting rather than two or three separate paintings of the same subject sharing one piece of paper.

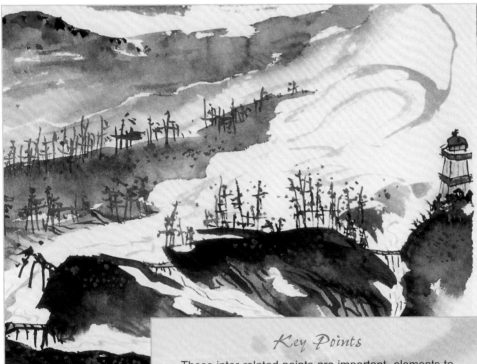

Space creates movement.

Keeping Watch, by Susan Frame.

Key Points

These inter-related points are important elements to consider when planning your composition:
white space; focal points; variety of shapes, angles and views; contrast; positioning of elements; color balance; movement and transition.

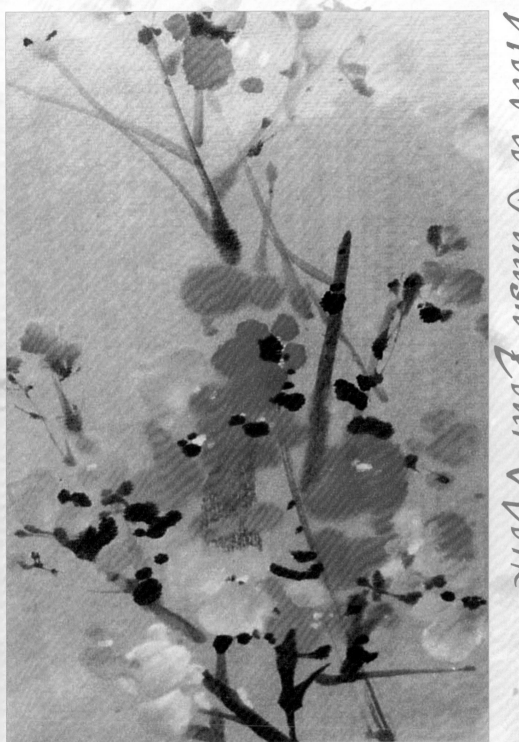

How to Finish Your Work

How to Finish Your Work

When your painting is finished and if you like it enough to keep it, sign it and then stamp it with your artist's chop (seal). If you want to use Asian calligraphy, you'll need help to translate your name into the appropriate characters. You'll also need a lot of practise to write it skillfully. It is a shame to ruin a good painting, so you might consider signing your name in English. You can still sign your name vertically, if that suits your painting better. You can also brush-write in the usual, horizontal way. The calligraphic quality of your English brush-writing should still be strong, but that may be easier to accomplish.

Inside Passage, Alaska, by Susan Frame. A vertical-format signature.

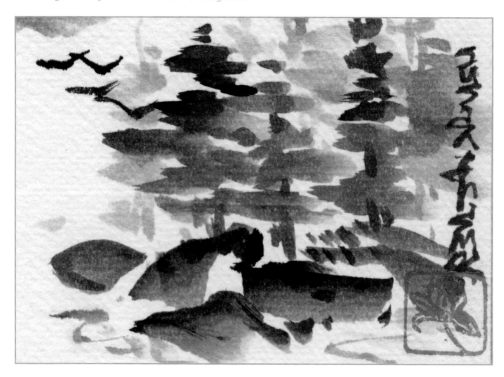

Seal-carving is an art in itself. Various materials are used, including soapstone, jade, and wood. Sometimes the top of the seal is carved in an animal form. Chops come in different sizes and different shapes. They can be square, rectangular, circular, oval, or irregular. They vary in size from a few inches across to a fraction of an inch. Some artists carve their own chops. If you want to carve your own, you can buy blank soapstone seals, carve an eraser, or use baking clay. I have even been known to use a wine cork when

teaching. The design has to be somewhat abstract because the cork disintegrates very easily, but it is fun to use when you are a beginner.

You may also want to use an artist's chop with which to finish your painting. Artists usually have many seals. Their choice depends on the painting, the design element, and the mood of the day. Artists' seal designs include full names, nicknames, poetic sayings, natural renditions, or abstract designs.

Chops, seal inks, and chop marks on paintings.

Inside Passage, Alaska, by Susan Frame. A vertical-format signature.

A lily stamp because in English
the name Susan means "lily".

Susan's maze of life.

Susan Frame.

Wine cork carved in an abstract tree
image at a landscape workshop.

Red seal ink is made from plant fibre, vermilion and oil. Good-quality seal ink will stand out on the paper even when stamped on top of dark ink. Colours range from rosy red to red-orange.

Traditionally, your signature and chop are part of the painting, and their placement is an important aspect of the composition. In a sense, they balance the painting. When thinking about where to sign and chop, look at the unpainted space on your paper. Determine which spaces are important to the breath of the painting. Do not sign and chop in those spaces. To help you to decide, sign your name and use your chop on a separate piece of paper. Now place that little piece of paper in various areas of your painting to see how it looks.

You are probably wondering about the use of calligraphy in Asian paintings. It appears to be, and is, much more than a simple signature. Traditionally, artists include a poem or some words describing the inspiration of the painting, as well as the month, day and year. Some contemporary artists complete paintings without this traditional calligraphy, and sometimes even without the traditional chop. Feel free to use your own personal style to complete your painting.

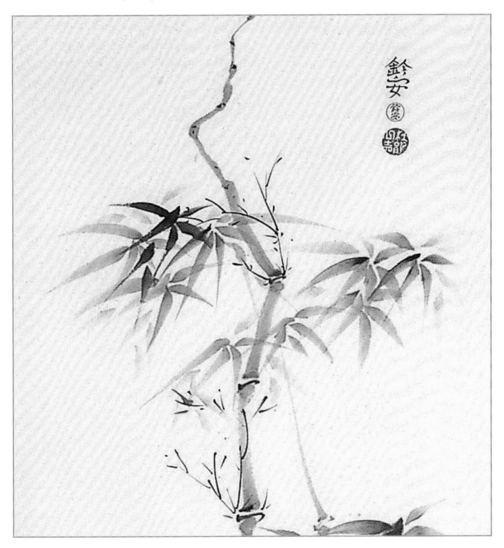

Mounting and Paper Stretching

Your painting is finished, you've signed it and you'd like to prepare it for framing. However, you notice wrinkles around the brush strokes where the water has dried. To get rid of the wrinkles, the paper needs to be stretched. Paper-stretching also adds depth to the painting and makes the shades of ink and colour appear more vibrant.

Paper-stretching is also called mounting. Don't use your masterpiece for your first mounting experiment. The first time around, you should expect things to go wrong, so don't be disheartened. It may seem stressful, but after a few times you'll get it. It can be easier to do with the help of another person.

Preparation

Wide, white-hair (sheep) brush.
Wide stiffer brush (I use a French house-painting brush or an elephant brush).
Stiff brush made from palm fibers (optional).
Needle or large pin.
Dry, unmixed wallpaper paste or a wheat-paste gravy made by cooking wheat flour, water, and a little ammonia as a mold retardant and pesticide.
You may use rice starch instead of wheat flour.
Container to hold paste, such as a shallow baking pan or a shallow plastic storage container (rectangular is better than round).
Blender.
Plywood board, hollow-core door, or finished cupboard door at least 6 in (15cm). larger than the painting.
Clean, smooth table, counter, or work surface made of Formica, glass, or finished wood, with good lighting.
Spray bottle with water.
Mounting paper: must be a strong, flexible paper like mulberry, linen, masa, or thick xuan.
Paper towel or sponge.
Straight edge for cutting.

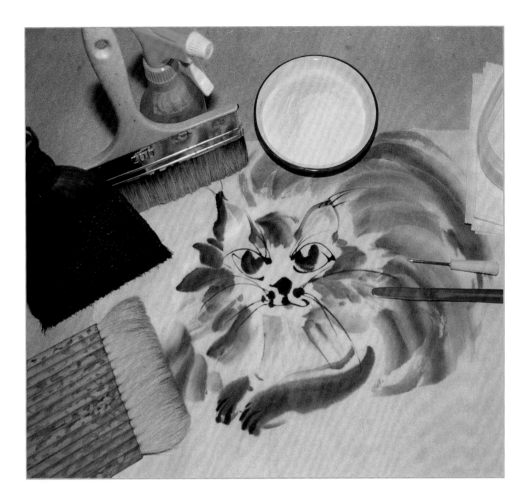

Make the paste. Experience will teach you the right consistency. It should be of a medium thickness. Begin by putting water in a blender. (You can make paste without a blender, but the blender mixes it much more easily.)

If you're only mounting one painting, start with a couple of cups of cool water, at least enough to cover your blender blades. Add dry paste or gravy to the water a little at a time, mixing as you add. Blend at a low speed to prevent getting too much air in your mixture. The fewer bubbles, the better. The desired consistency is not really thin or really thick. The paste should have a slippery feel and should drip slowly off a spoon or brush. Pour the paste into the shallow container and let it sit while you prepare the paper. If it's very frothy, let it sit a while longer to settle down.

Using a straight edge, tear the mounting paper to size. The correct size is about 2 in (5cm). larger on all sides than your painting.

Save the scraps and rip them into 2- or 3-in. pieces. You'll need them later as corner-reinforcers. Set the mounting paper and corner-reinforcers aside.

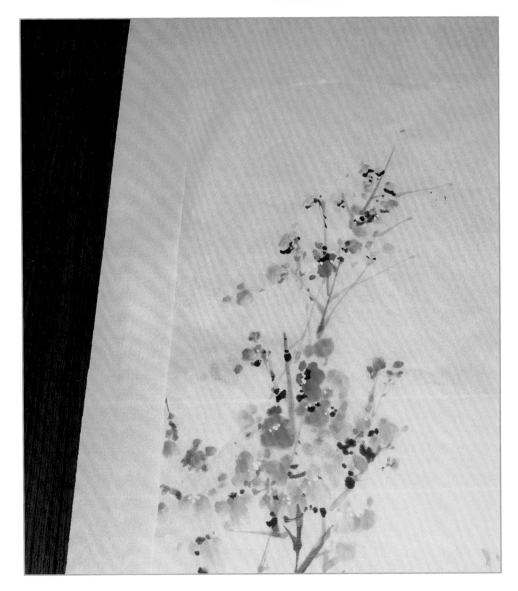

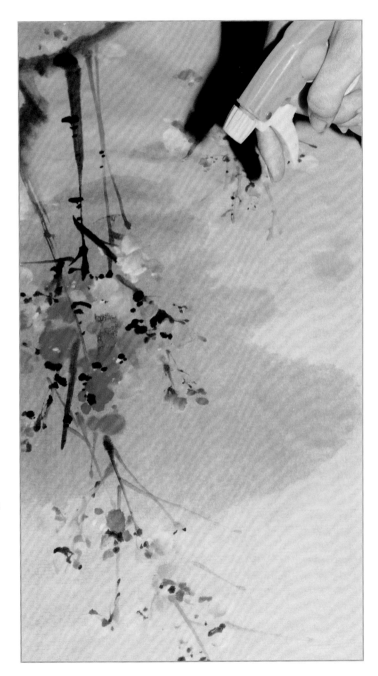

Lay your painting face down and gently smooth it with your hands. Mist it with your spray bottle and carefully straighten it. The sprayed water will settle into the paper and soften it, making it more pliable. Don't try to remove all of the wrinkles, just straighten the paper. From this point on, be very careful when handling your painting. The paper will stretch very easily, possibly in ways that you don't intend. Also be careful about pulling the paper: it's very fragile and will rip easily.

Fill the wide, white-hair brush with paste and drag it across the edge of the container to remove the drips. Don't remove too much as you don't want a dry brush. If the paste is mixed correctly, it should slide easily across your paper without leaving clumps or dry spots. If it doesn't slide and looks watery, add more paste to your mixture.

Apply the paste to the back of the painting, beginning in the middle. Use a flicking movement of the brush, starting with one stroke in the center of the page. Working stroke by stroke, flick one stroke to the side, then another stroke, then another. Your touch should be light and feathery, like a butterfly.

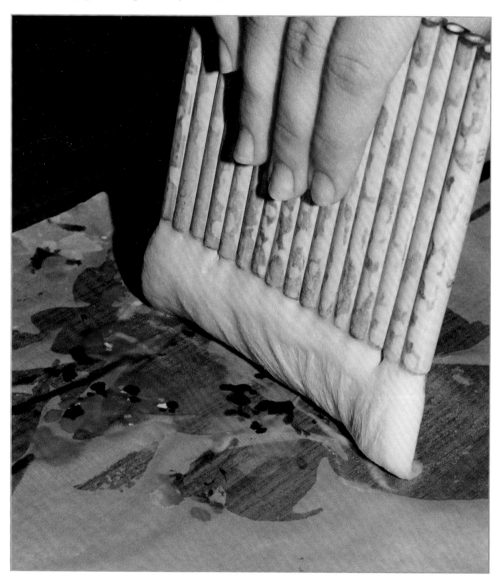

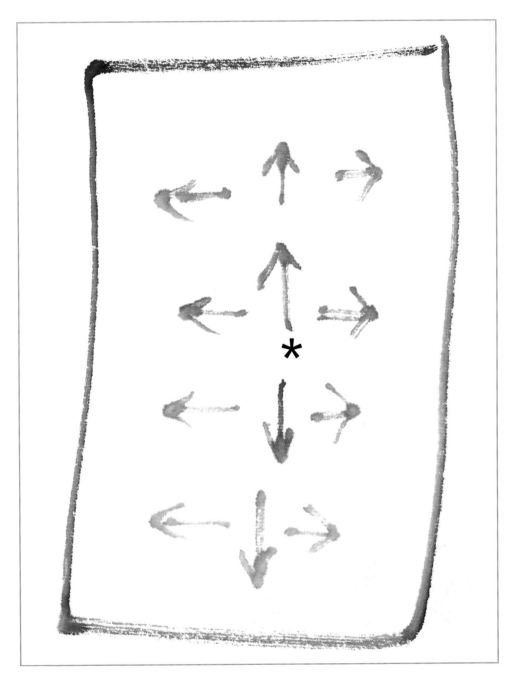

* Begin here

Refill the brush frequently with paste. If your strokes are correct, you are pushing the air out ahead of the brush and are actually stretching the paper as you go. Go slowly because if you go too quickly you will run over the air bubbles and they will become creases. Creases are difficult to remove. Continue stroke by stroke until the brush is off the edge of the paper. Be sure to go off the edge so that the air is totally pushed out from under the paper.

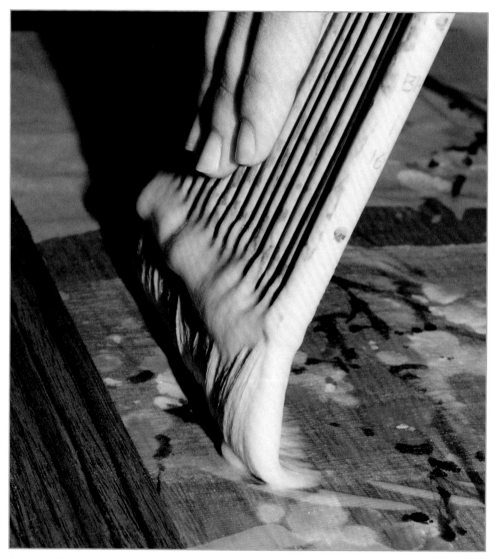

Apply paste off the edge of the paper.

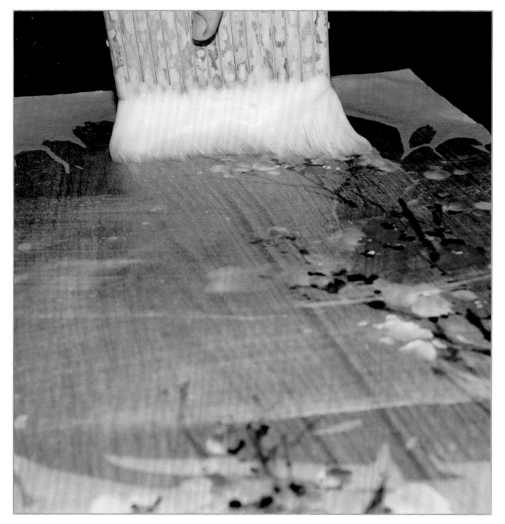

Work your way to the end of the paper as you apply the paste.

Go back to the first middle stroke and work outwards, to the other side of the paper, using the same kind of flicking movement. Now you have completed a "row". Start the second 'row' in the center, next to the very first stroke, and flick towards the end of the paper. Follow on one side, then the other, as before. Go back to the middle and start the third "row". Work your way to the end of the paper. If some creases are created along the way, leave them to work on later.

After you've completed half of the painting, go back to the center and work towards the other end of the paper, using the same procedure. Stroke slowly and work with deliberation because if you move too quickly the paper may rip or crease and the color could run.

When you have finished applying the paste to the whole of the painting, set down the brush and look carefully for creases, wrinkles and bubbles in the paper. If you don't find any, consider yourself lucky. If you do find a crease, carefully stretch it out by stroking lightly away from it, using the brush to pull the paper. Use lots of paste and try to avoid stroking directly over the crease because that usually makes the problem more severe. Sometimes you'll need to brush-stroke the length of the crease to try to move the air out of it.

When all of the creases are out, set down the brush again and examine your painting carefully. Look for big and little hairs that may have floated on to the paper and remove them. Sometimes they're difficult to see, so look very carefully. They may seem inconspicuous now, but when the painting is dry they'll be very noticeable.

Lay the rolled mounting-paper edge down.

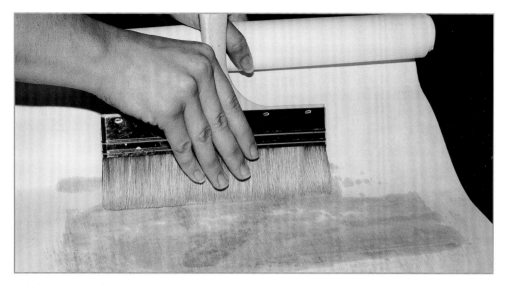

Push the paper down with the brush.

By now you may have made a mess on the table with the paste. Using a paper towel, clean the area surrounding the painting. Roll up the mounting paper and position it over your painting. The paper should be in your left hand and you should start at the right end of your painting. Lay the edge of the mounting paper down on the table, about 2in (5cm). beyond the end of the painting. Holding the rolled mounting paper in one hand, pick up the dry, wide mounting brush, (the French house-painting brush) with your other hand and apply small, flicking strokes up the centre of the paper. Use the same directions as for applying the paste, up the center and from side to side, slowly unrolling the paper as you go. Your butterfly strokes will push the mounting paper on to the painting.

Don't lay the paper down until the brush pushes it down. If you lay the paper too fast, bubbles will appear between the mounting paper and the painting paper. Be sure to brush everywhere because any place that you miss will become an air bubble. But don't overdo it because brushing over and over again is not good for your fragile painting.

Make sure that the mounting paper is firmly glued to the edges of the painting. I brush across every inch of every edge to make sure that there are no hidden bubbles and that the pieces are pasted together. Now apply paste to the edges of the mounting paper. There should be about 2in (5cm). of mounting-paper border surrounding the painting. Apply paste all the way round the border, but don't let it touch the painting. Check that you haven't missed any spots.

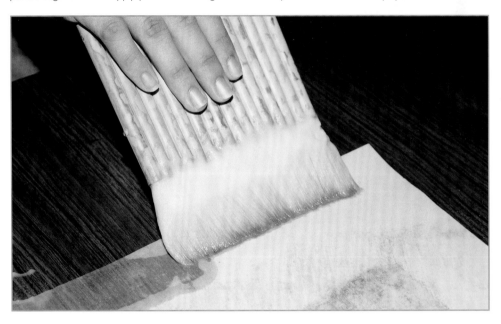

Now you're ready to pick up the painting and paste it to the plywood board. The painting will hang vertically, not horizontally, so the manner in which you pick it up is important. Stand at the end of the painting. Use your inside hand to lift the inside corner of the mounting paper and the corner of the painting. You may have to use the needle to lift it. While holding this corner, reach across and pick up the corner-reinforcer (a scrap of mounting paper) and the stiff, palm-fiber brush. Use the brush to pick up the far corner of the painting. The corner-reinforcer should be between the brush and the painting, with the brush in front and your fingers behind the painting. Now you have one corner in one hand and the other corner in the other hand. Walking next to the table, lift the painting off the work surface. Continue walking and lifting until the painting is completely off the work surface. The entire motion should be fluid, from the time that you begin picking up the first corner until you finish pulling the painting off the table. The slower you move, and the more the wet paper hangs in one position or another, the more it will stretch, usually to the detriment of your project.

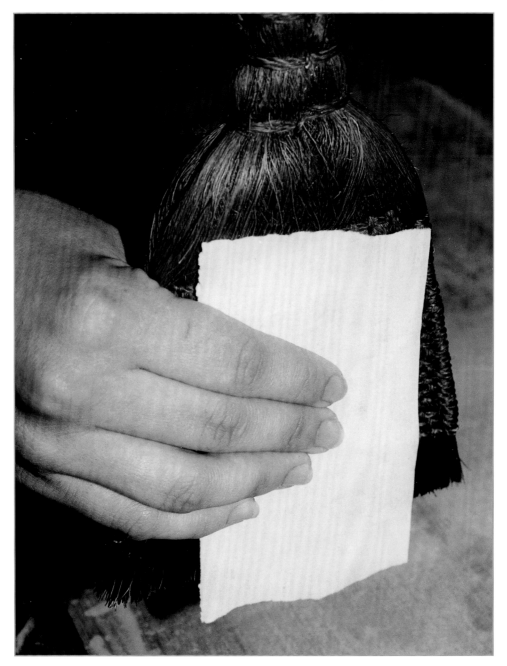

A corner-reinforcer and brush.

Pcking up a corner with a corner-reinforcer and brush.

When you've finished lifting the painting off the table, it will be hanging down in front of you. The front side of the painting will be facing you. Walk carefully to the plywood board (propped-up vertically), door, or cupboard door. Attach the top of the mounting paper to the board first and don't let go with either hand. Using the palm-fiber brush (which should still be in one hand), brush in an upward movement to attach that corner. Don't let go of the other corner while you brush across the top of the mounting paper. Your strokes should begin about 1in (2.5cm) from the edge of the painting and go outward, past the edge of the mounting paper.

Once the top edge has been pasted, let go. Work down the side of the paper, down the other side and across the bottom. Brush only the borders, not the painting itself. Make sure that the borders are securely stuck all of the way around because the painting may buckle if they are not. Be careful not to pull too tightly with your strokes. A layer of air should be between the painting and the board. If the painting is pulled too tightly, there's no layer of air and it can tear while drying. If your painting seems tight, pick up a corner of the painting and, using a straw, blow underneath to create an air pocket. Be sure to re-glue the corner.

Is it mounted correctly? The painting should be facing you and the mounting-paper borders should be pasted tightly to the board. Now it needs to dry. As it dries, it will tighten up like a drum and all of the wrinkles will disappear. How long this will take depends on a number of variables. How big is your painting? What kind of paper is it painted on? What part of the world do you live in? How much moisture is in the air? If you live in a dry part of the world, run a humidifier because it's important that the painting doesn't dry too fast. If you live in a humid area, run a dehumidifier or an air-conditioner to help it to dry. You could also try a space heater and a fan if the temperature allows it.

The painting will need to dry for a minimum of 24 hours and sometimes takes a week or longer if it's very large. Don't take the painting off the board before it is dry or it will buckle. You can tell if it's dry by touching your hand lightly to the surface. If it feels cool, or damp, it is not dry. When it's totally dry, cut it off the board using a blade or knife.

Frame your Sumi-e as you would a watercolor, with a mat covering the edges of the painting, a frame and glass or Plexiglas. Beware of frame shops that tell you that they can stretch your painting or mount it properly. Very few framers know how to do this. They will often try a dry-mount process, which will not only detract from the painting's value, but will create permanent creases. It is really worthwhile learning how to do your own stretching.

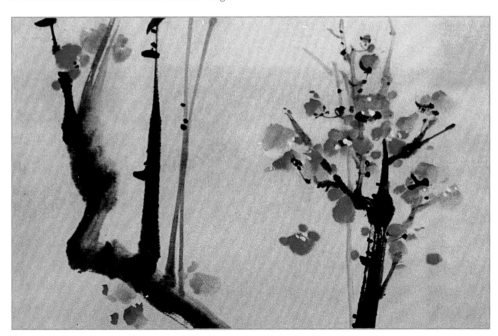

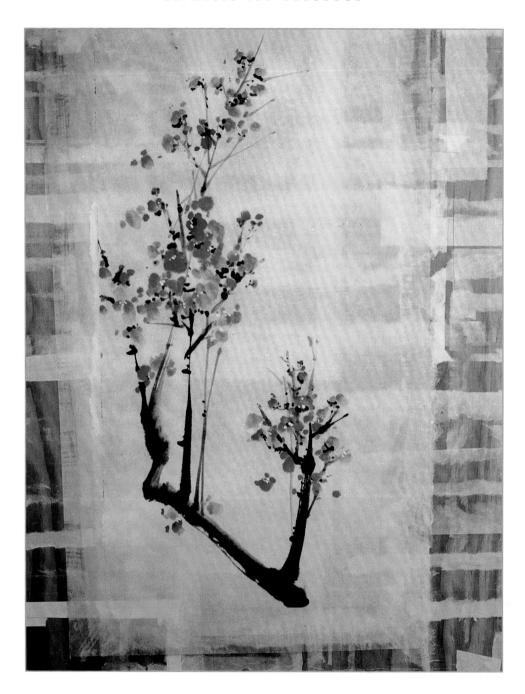

Gallery of
Student Work

We are all students of life. Learning to paint is a lifetime pursuit, an up-and-down pathway of risk and failure, filled with joy and new discoveries. The creation process will bring a deeper understanding of yourself and the world around you. The student works shown here communicate their perseverance in learning, as well as their joy in painting.

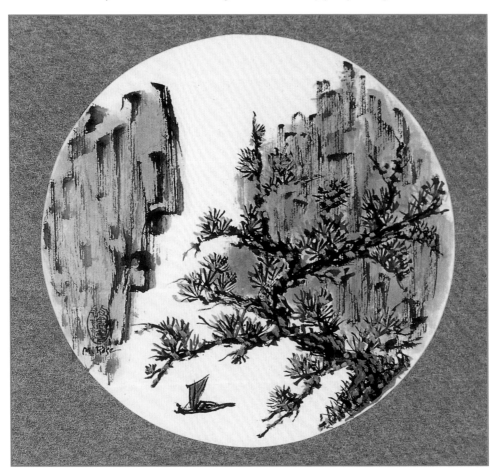

Landscape, by Margery Rose.

A Winter's Moon,

by Pedro L Vera.

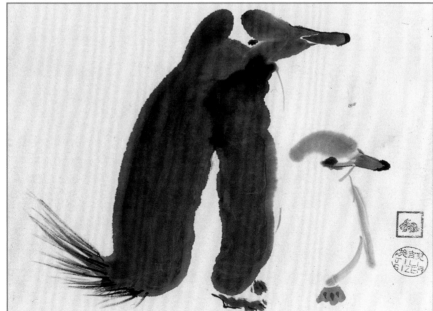

Penguins,

by Jill Sizer.

*Tree Frog,
by Elin Ohlsson.*

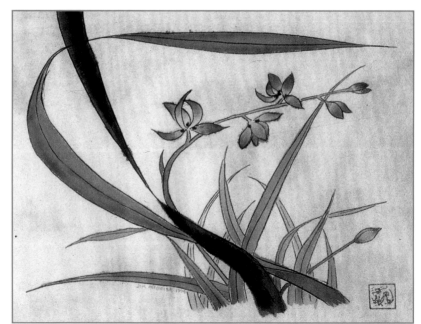

*The Gentle
Breeze,
by Jim McGuire.*

The Dragon is a Water Spirit, by Edith Hollyday.

Lighthouse, by Bess Hum.

Contemporary Inspirations

Sumi-e is tradition, but it is also about growing out from those roots and expanding your creative expression. The path of an artist is one of challenge, fuelled by the desire to move into different territory. The world of Sumi-e encourages growth and personal expression. Begin with strong ink and brushwork, then build on that and charge ahead to find your own style and your own way. Push your boundaries and try new subjects, colors and techniques. Don't be afraid to break the rules in your experimentation. These works are contemporary because they exhibit strong personal style, make use of innovative techniques and interpret the world with a fresh eye.

Bridal Bouquet, by Susan Frame.

Birches Along the Gunflint Trail, by Mary Rodning.

Warm Winter, by Susan Frame.

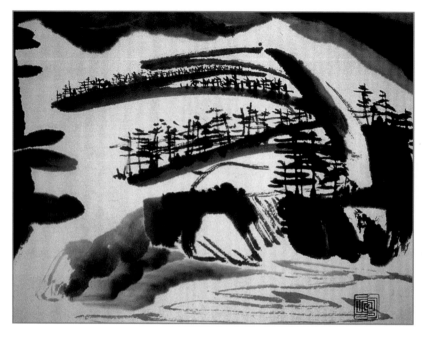

Full Moon, Night
on Day,
by Susan Frame.

Lake Superior,
by Susan Frame.

Aspen, Early Spring, by Susan Christie.

Brown's Creek, by Susan Frame.

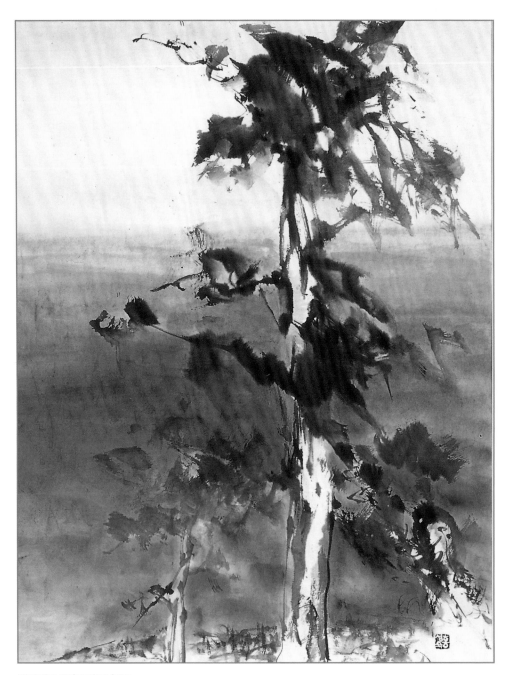

Windy Day, by Sung-Sook Setton.

last brush stroke - -
crossing moonlit shadows
on the chime of windbells

By Charles Bernard Rodning.

Mums and Plum in Blue Vase by Kay Stratman.

Index

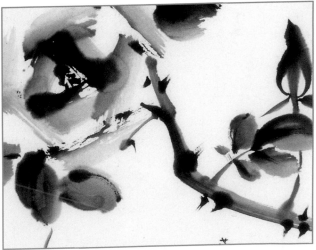

Suggested Reading

China, A History in Art, Bradley Smith & Wan-go Weng, published by Doubleday & Company, Inc, © 1979.

Understanding Chinese Painting, T C Lai, published by Shocken Books, © 1980.

The Way of Chinese Painting, Mai-mai Sze, published by Random House, Inc, © 1959.

Chinese Seals, T C Lai, published by University of Washington Press, © 1976.

Washi, The World of Japanese Paper, Sukey Hughes, published by Kodansha International Ltd, © 1978.

The Art Of Sumi-e, Shozo Sato, published by Kodansha International Ltd, © 1984.

Japanese Ink Painting, Ryukyo Saito, published by Charles E Tuttle Co, Inc, © 1959.

The Art and Technique of Sumi-e: Japanese Ink Painting as Taught by Ukai Uchiyama, Kay Morrissey Thompson, published by Charles E Tuttle Co, Inc, © 1960.

Chinese Watercolours, Joseph Hejzlar, published by Octopus Books Ltd, © 1980.

Chinese Brush Painting, Pauline Cherrett, published by D & S Books, © 2000.

Japanese Brush Painting in Color, Kohei Aida, published by Japan Publications, Inc, © 1973.

The Mustard Seed Garden Manual of Painting, Kai Wang, published by Princeton University Press.

Zen and Japanese Culture, Daisetz T Suzuki, published by Princeton University Press, © 1959 by Bollingen Foundation Inc.

The World of Zen, Nancy Wilson Ross, published by Random House, Inc, © 1960.

Video: **Mounting Techniques for Oriental Brush Paintings,** Judith Laughlin. laughlin@pressenter.com or PO Box 900, Ellsworth WI 54011, USA.

Organisations:
Sumi-e Society of America: www.sumiesociety.org
Chinese Brush Painters Society: www.cpbs.co.uk
Sumi-e Artists of Canada Inc:
www.geocities.com/ResearchTriangle/Thinktank/2086/index.html
My website: susanframe.com; undercoverartists.com

Credits and Acknowledgements

Many thanks to friends and family who gave advice, proofread, edited and inspired. In no particular order, thanks to Rocks, Elin Ohlsson, Diana Hedges, Pedro L Vera, Kay Stratman, Stephanie Henderson, Don Naumann, Bess Hum, Alta Hanson, Marge Rose, Susan Christie, Dorothy Frame, Len Frame and Neveta Henderson.

Thanks also to the artists and poets who consented to being included in this book: Jeanne Emrich, Charles Rodning, Mary Rodning, Sung-Sook Setton, Kay Stratman, Susan Christie, Susan Lasley, Judith Laughlin, Cecil Uyehara, Jeanne Emrich, Pedro L Vera, Jill Sizer, Elin Ohlsson, Margery Rose, Jim McGuire, Edith Hollyday, Bess Hum, and to my teacher and good friend Zhuo He Jun.

Photography by Susan Frame and Don Naumann.

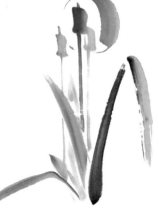